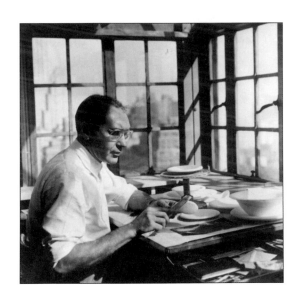

Russel Wright working on a pottery line in his New York studio, 1946.

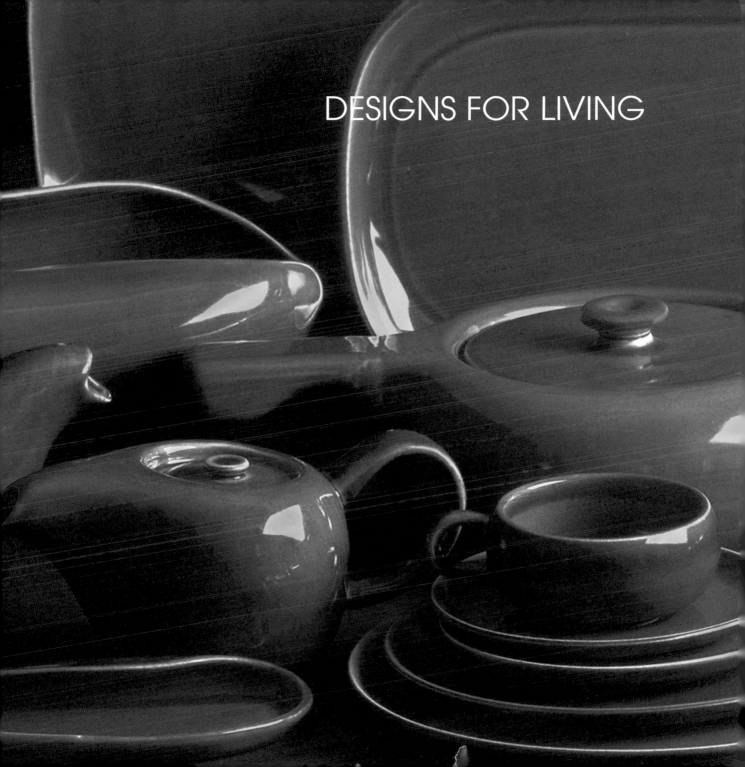

DESIGNS FOR LIVING

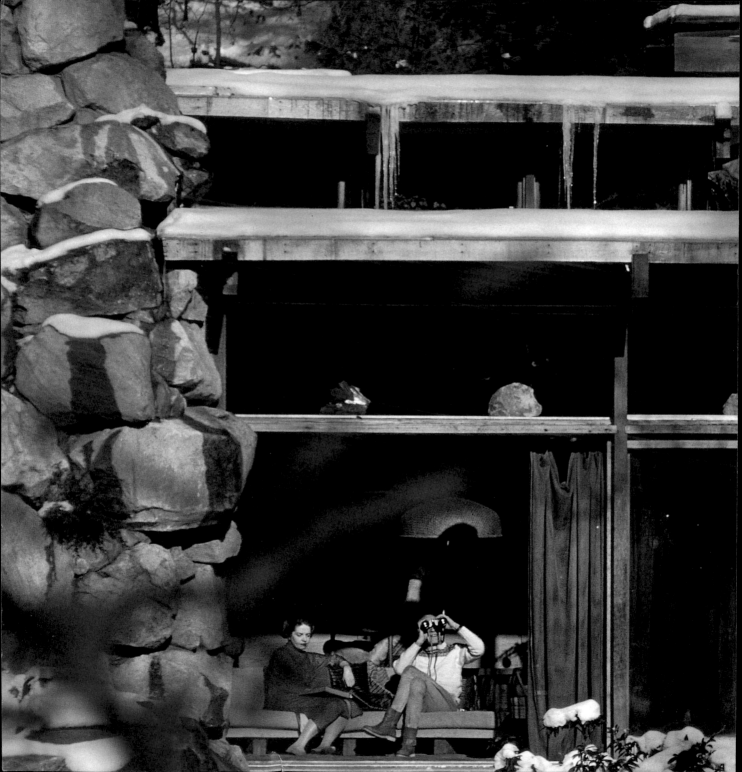

HOME

WOODLAND GARDEN

RUSSEL
WRIGHT:
GOOD
DESIGN
IS FOR
EVERYONE

IN HIS OWN WORDS

Design and photo editor:
Joe Chapman
Text editor: William Zeisel
Computer Graphics: Lynn Carano
Color product photographs: Masca
Home and landscape photographs:
Adam Anik, Steven Bates, Halley
Erskine, Carol and Colin Franklin,
Alexandre Georges, Farrell Grehan,
Robert Glenn Ketchum, and
Louis Reens
Copyeditors: Stephanie Schwartz
and Jaye Zimet
Printer: The Offset House

RUSSEL WRIGHT: GOOD DESIGN IS FOR EVERYONE

DESIGNS FOR LIVING,
HOME, WOODLAND GARDEN

IN HIS OWN WORDS

WITH INTRODUCTORY ESSAYS BY
DIANNE H. PILGRIM, MALCOLM HOLZMAN, AND IAN McHARG

MANITOGA/THE RUSSEL WRIGHT DESIGN CENTER
UNIVERSE, A DIVISION OF RIZZOLI INTERNATIONAL PUBLICATIONS

First published in the United States of America in 2001
by Manitoga/The Russel Wright Design Center and
UNIVERSE PUBLISHING
A Division of Rizzoli International Publications, Inc.
300 Park Avenue South, New York, NY 10010

This book is made possible with public funds
from the New York State Council on the Arts,
a state agency.

A Note on the Texts: Two of Russel Wright's essays are reproduced in their entirety:
"Philosophy of the House" and "Garden of Woodland Paths." The others have been
presented in abridged form, but without changing Wright's words except to
correct obvious typographical errors and misspellings. Copies of Russel Wright's
writings are available for examination at Manitoga/The Russel Wright Design Center,
in Garrison, N.Y.

2001 2002 2003 2004 2005 2006 / 10 9 8 7 6 5 4 3 2 1

Printed in U.S.A.

Library of Congress Cataloging-in-Publication Data

Wright, Russel, 1904-1976.
 Russel Wright: good design is for everyone—in his own words:
designs for living, home, woodland garden / with introductory essays by
Dianne H. Pilgrim, Malcolm Holzman, and Ian McHarg.
 p. cm.
 ISBN 0-7893-0654-9 (pbk.: UnivPerm alk. paper) -- ISBN 0-9709459-1-4
(pbk.: ManiPerm alk. paper)
 1. Wright, Russel, 1904-1976. 2. Design--United States--History--20th century.
I. Title: Good design is for everyone. II. Pilgrim, Dianne H.
III. Holzman, Malcolm, 1940- IV. McHarg, Ian L. V. Title.
 NK1412.W75 A35 2001
 745.4'492--dc21 2001003363

Manitoga/The Russel Wright Design Center
P.O.Box 249, Garrison, N.Y. 10524
Phone 845.424.3812 Fax 845.424.4043
Email info@russelwrightcenter.org
www.russelwrightcenter.org

CONTENTS

FOREWORD

BY DAVID McALPIN
President of the Board, Manitoga/The Russel Wright Design Center

Art as Teaching

The best artists are also teachers. They ask us to look at the same old world with new insight. They encourage us to appreciate the landscape and our interaction with it. They enable us to become aware of our relationship with our setting. They inspire us to better our lives through art and a deeper understanding of our place in the world.

During the first half of the 20th century, the United States produced a cohort of outstanding artists who dramatically raised the level of American design. Artists such as Raymond Loewy, Walter Dorwin Teague, and Norman Bel Geddes created designs for objects, appliances, and buildings that brought to the American public a style of life incorporating good modern design. Almost incidentally, they also helped create the field of industrial design, which melds the inspiration of the artist with the mass-production mentality of the engineer.

Wright the Educator

Russel Wright (1904–76) was arguably the most influential of this remarkable group of artists. RW stressed the importance of understanding one's immediate surroundings and interaction with it, whether it be a kitchen counter, a tree, a place setting, or moss on the forest floor. He educated tens of millions of Americans through his pioneering, modern household wares—from furniture to ceramics and plastic ware—which he created not for the elite but for a middle class that was ready for innovation. Beginning in the late 1920s and extending through the 1960s, RW created a succession of artistically distinctive and commercially successful items that helped bring "modern" design to the general public, not as museum exhibits but as part of the home.

With American practicality RW and his wife Mary went beyond the design of specific items to imagine an entirely new approach to arranging the house and its daily routine. They called it "easier living," and based it on new fabrics and materials like plastics and formica. With matchless timing, they championed a more informal style of living, just when Americans were looking for a lifestyle that was flexible, open, and congenial.

RW also educated Americans about the outdoors, both as a visual experience and as a place of discovery and recreation. Years before "ecology" became part of the vernacular, he began creating a full-scale setting in which people could experience his vision of intertwined human and natural worlds. In 1942 he purchased some 75 acres of desolate, ravaged forest land In Garrison, N.Y., about an hour's drive north of his New York City townhouse and studio, and began

reshaping it into an exquisite natural garden. He called the retreat Manitoga, "Place of the Great Spirit" in the Algonquin language, and in 1957 asked architect David L. Leavitt to help him design a house and studio that would be intimately based on its site, fostering not only visual harmony with the land but also enhancing the natural features. In 1961, RW and his daughter Annie moved into the house, which he named Dragon Rock after hearing Annie remark that a large rock outcropping in the quarry looked like "a dragon drinking water."

RW's evident success in joining human and natural values gave him a second career as a consultant about public parks. "My whole new career and philosophy is to help educate people to get enjoyment from the parks," he said in an interview about "Summer in the Parks," a program of concerts, movies, and other public activities that he originated in Washington, D.C., in 1968, for the National Park Service.

RW extended his philosophy of public access and use to his own property. In 1975 he bequeathed Manitoga to The Nature Conservancy. Ten years after his death, Manitoga became an independent, nonprofit organization, and it is now being developed as a center for educational programs about design and nature based on RW's process and work.

Wright's Words and Designs

We at Manitoga are pleased to offer this book as an introduction to the three most influential and enduring aspects of RW's art—designs for living, home, and woodland garden. Unlike other books about RW, this one speaks mainly in the artist's own words and images. RW did not consider himself a writer, yet he wrote many essays and lectures, some of which were published, that give first-hand accounts of an American cultural and artistic revolution. We have reproduced two of these essays in their entirety and several more as condensed excerpts. Combined with photographs of his designs, they offer insight into the creative process and afford the pleasure of having a gifted artist talk about his own work.

To provide a context for RW's words and designs, we asked three experts to write introductions for the main topics of the book. Dianne H. Pilgrim has written about RW's roots in craftsmanship and his place in the evolution of American

design during the mid-20th century. Malcolm Holzman applies an architect's perspective to understanding RW's approach in imagining Dragon Rock. And Ian McHarg places Manitoga within the milieu of ecologically inspired design, as "an exemplar for all designers and landscape architects, and for all ecosystems waiting to be idealized and appreciated."

Acknowledgments

Many people and organizations have helped make this book possible. We thank the New York State Council on the Arts for major funding to support the costs of writing, design, and printing. We also thank Agnes Bourne for a very generous grant, given, she notes, "because design matters." RW's close friend Margaret Spader provided advice and support from the start. The book's elegant design was done as a gift to Manitoga by Joe Chapman, for many years RW's companion, who also offered invaluable advice and counsel. We owe much to Annie Wright for writing the Preface and providing key advice. Bill Burback chaired the committee that oversaw the book's creation, with assistance from Board members Dennis Mykytyn and Bill Straus and former Board member Doris Shaw. We also express our deep appreciation of the late Herb Honig, one of RW's close business associates and a Manitoga Board member. Consultant Suzann Dunaway advised us about fundraising and other matters.

We gratefully acknowledge important advice and information received from Donald Albrecht and Robert Schonfeld, co-curators of a major exhibition about RW that opens in November 2001 at the Cooper-Hewitt, National Design Museum, Smithsonian Institution. We thank Ann Kerr, David Ross, Joe Keller, Jim Drobka, Cindy Fahnstock and B.A. Wellman for invaluable assistance. Executive Director Anne Impellizzeri tirelessly moved the project forward.

Although we present here a unique view of a remarkable artist, the book's real value is to remind us that RW's finest creations remain as fresh and provocative today as they were decades ago. His direct and efficient approach to design produced works that remain useful, attractive, and highly prized by collectors and museums. Manitoga retains its ability to amaze, enchant, enhance, and inspire us to live more fully. In the final analysis, they teach us how to live a better life.

PREFACE

BY ANNIE WRIGHT

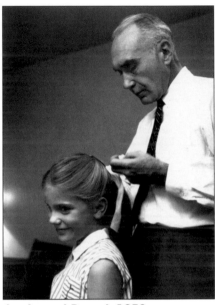

Annie and Russel, 1958.

My father revolutionized the way Americans live and organize their homes. By bringing great design to the mass market, and encouraging greater pride in home-grown creativity without borrowing from European styles, he transformed our understanding of good American design. At a personal level, our small family practiced the appreciation of American design on a daily basis. In fact, it was not until I was nine or ten that I even understood there was a "European style." From my point of view, there was only the "Russel Wright style," which was what we lived and what the rest of the world ought to live, if they didn't already.

Russel devoted his life to his art. I saw that facet of him all the time. Yet, although Russel practiced at the center of a glamorous, international profession, he was a homebody who did not like to travel. Amid all the activity of his business, he found private time, often in the garden at Manitoga.

As I got older, I began to see that my father's artistic brilliance and success were the public aspects of a complicated set of personalities and relationships. Two key people enabled Russel to turn his great talent into a business success. They were Mary Einstein Wright and Irving Richards. My mother, Mary, was a natural saleswoman, who, being a creative designer herself, understood the Russel Wright message and product. Side by side, Mary and Russel tackled the American public. And without their great and loyal friend Irving Richards, we might never have met Russel Wright. Irving's marketing genius, coupled with his business savvy, gave Russel a business partner anyone would be thankful for.

Following Mary's death, two friends enriched Russel's life. Margaret Spader, a distinguished home economist, visited many weekends and was instrumental in preparing Russel's book of menus and coordinated table settings. Graphic designer Joe Chapman helped Russel develop the trails at Manitoga and drew visualizations and illustrations with him for projects at Manitoga and beyond.

I must also mention Russel's and my beloved cousin Carol Franklin. Her stubborn devotion to Manitoga and her intellectual comprehension of Russel's work have given us our master landscape plan, and her wit and ingenuity, together with her husband Colin and their prestigious firm, Andropogon, have promoted our vision considerably.

My father had an uncanny ability to predict consumer tastes—until the 1960s when his designs no longer found wide success. I recall his puzzlement and frustration during those years. He found a new cause in his work creating Manitoga as a model of design that integrated the natural with the human, as he believed that millions of city dwellers shared his desire to escape the sensory overload of modern life. In this, and in so many things, he was ahead of his time.

Today, his time seems to be returning again, as collectors, museums, experts, and the public rediscover his art. I am pleased that Manitoga is in the process of becoming a museum and exhibition space, through which the creations and ideas of my parents can be shared with all Americans, whom they viewed as their principal customers.

RW: CHRONOLOGY
OF A LIFE IN DESIGN

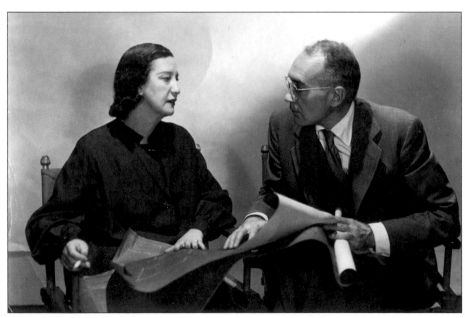

Mary and Russel, 1951.

1904	Born in Lebanon, Ohio.
1920–24	Studies at Cincinnati Academy of Art, Art Students League in New York City, and Princeton University. Begins working in theater and costume design with Norman Bel Geddes and Aline Bernstein (who taught him "to do a small job perfectly").
1927	Weds Mary Small Einstein, who becomes his business manager and most ardent publicist.
1927–29	Starts home accessories design business in New York City, and begins creating objects for the home: cast metal animals, and informal serving accessories in spun aluminum and other materials.
1930s	Designs products including the popular American Modern line of furniture and a piano and radio for Wurlitzer.
1939	Introduces American Modern dinnerware, in its day the largest selling line of dinnerware made in the United States. Establishes Raymor firm with Irving Richards to distribute home furnishings designs. Designs exhibitions for New York World's Fair.
1942	Purchases land in Garrison, N.Y., as site for a weekend retreat, Manitoga.
1945	Designs prototype set of Melamine dinnerware, one of the first dinnerwares made of plastic.
1946	Introduces Casual China, one of the first lines of "unbreakable" dinnerware.
1950's	Begins developing an ecologically attuned woodland garden at Manitoga; plans his home and studio, Dragon Rock.
1950	With Mary writes *Guide to Easier Living*, describing how to reduce housework and increase leisure through efficient design and management.
1952	Mary Wright dies.
1953	Receives MoMA Good Design Award for Residential line of plastic ware—one of several awards from the Museum of Modern Art.
1955	Visits Southeast Asia for U.S. State Department to examine ways of increasing handicrafts exports to the United States.
1957	Begins building Dragon Rock with architect David L. Leavitt of Leavitt, Henshell & Kawaii.
1968	At request of National Park Service develops "Summer in the Parks," a program of public activities to draw people into the parks of Washington, D.C.
1975	Announces opening of Manitoga trails to the public under supervision of The Nature Conservancy.
1976	Dies in New York City.

DE

L

SIGNS FOR IVING

A SINGULAR ARTIST

BY DIANNE H. PILGRIM
Director Emeritus and Senior Advisor for Special Projects, Cooper-Hewitt, National Design Museum, Smithsonian Institution

Russel Wright was an unusual combination of an American craftsman, industrial designer, and naturalist. Born of Quaker parents in Lebanon, Oh., he grew up and began his professional career during a period of profound changes, when Americans began enjoying the benefits of enormous new wealth but also suffered overwhelming dislocation. The years between the world wars were a time of restlessness as a result of so many conflicting feelings: uneasiness but hope, fear but exuberance, experimentation and innovation. This frenzy was obvious in the designs of the 1920s, from costumes to interiors to furniture and accessories. Then came the crash of 1929 and the Depression, when people felt a need for unity and a symbol of hope. Streamlining became that American symbol, representing the power and speed of the machine.

RW was very aware that the Depression had brought a totally different way of living, stripped of servants to polish the silver, handle the porcelain dishes with care, wash the clothes, serve the meals. His insight that Americans wanted homes that were well designed and easy to care for led him to produce a series of

housewares and furnishings—wrought of easily maintained materials like solid wood, spun aluminum, stainless steel, earthenware, paper, and plastic—that made him a household name. As he and his wife Mary, also a designer (as well as a brilliant businesswoman), noted in their pathbreaking 1950 book, *Guide to Easier Living,* "our main thesis here is that formality is not necessary for beauty."

An independent thinker, not a follower of the newest trends, RW helped create the concept of the industrial designer, an American phenomenon that emerged during the 1920s. An industrial designer is known for designing everything, for being a problem solver, and for being able to design for mass production. Unlike most industrial designers of his age, however, RW basically designed for the home with some work for offices, showrooms, and expositions.

RW also brought his special talents to bear on the relationship between design and natural settings. By the 1950s he was beginning to create an ecologically sensitive woodland garden on his estate, Manitoga, in Garrison, N.Y. During the 1960s he became a consultant to the National Park Service and focused on bringing people into the parks, to enjoy nature. At Manitoga he had already begun building a residence and studio, which he named Dragon Rock, to explore ways of bringing daily life closer to nature.

RW was a craftsman at heart who wanted to make household pieces that were beautiful, useful, reasonably priced, and available to everybody. And there was the problem, a problem he struggled with all his life. At times he thought of himself as a failure, but as this book shows, nothing could be further from the truth. Every newlywed couple from the late 1930s through the 50s knew his name, stamped on the bottom of their new china, along with all the other useful and handsome objects that made them proud to be Americans. Today his pieces are prized by museums and avid collectors everywhere.

Dianne H. Pilgrim has had a distinguished career as a scholar and museum director. Her many publications include The Machine Age in America *and* The American Renaissance 1876–1917. *She was curator and later chair of the Brooklyn Museum's Department of Decorative Arts, from 1973 to 1988, and then became director of the Cooper-Hewitt, National Design Museum, Smithsonian Institution.*

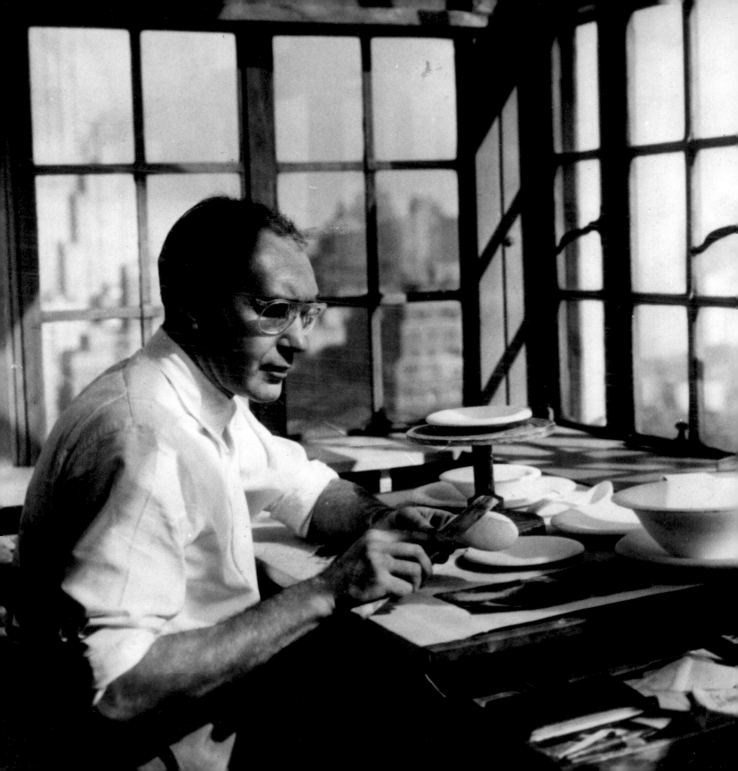

DESIGN FOR THE MASSES

In a television interview RW tells Edward R. Murrow how he began designing for the home. Excerpted from CBS television interview program "Person to Person," 1958.

Edward R. Murrow: For almost 30 years Mr. Wright has been a pioneer in modern design and in informal living, dominated by his notion of functional design for the masses, not the classes.

Murrow: How did you happen to concentrate on products for the home?

RW: Mary and I were a young and impecunious couple, and we did this out of necessity. We had to do our own housekeeping and furnish our own apartment. So I began designing and making furniture and serving-pieces for our own use. It was out of this furniture that I designed the first line of solid blonde furniture. It took me about a year to find somebody that would manufacture it. Macy's finally helped me. And it was such a great hit that many manufacturers started to copy it and have done similar things ever since.

Murrow: How many Wright dishes have been sold so far?

RW: Oh, we have no idea, when you consider the eight different lines and the various copies. But of this line (American Modern) we know that about 250 million pieces have been sold.

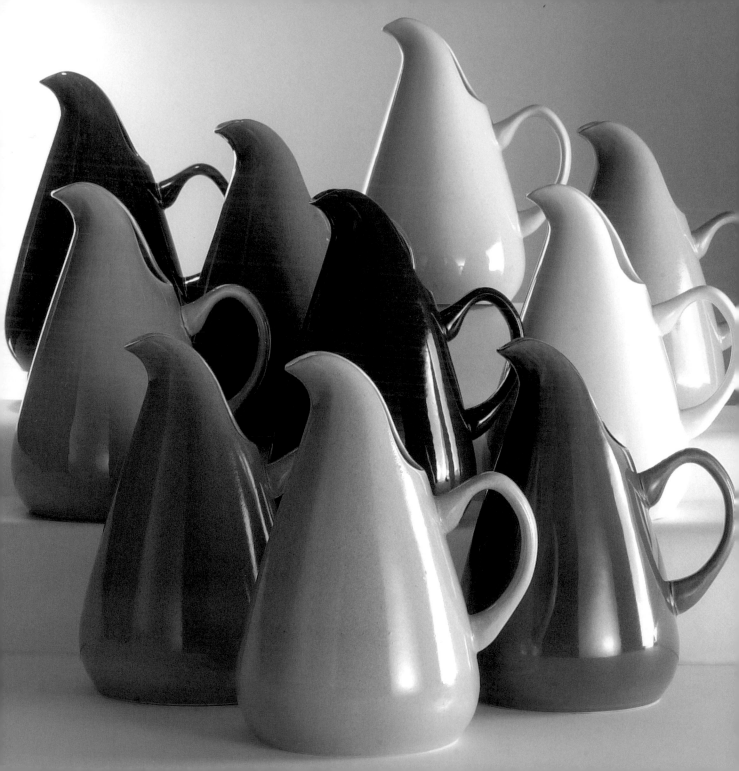

CREATING AN AMERICAN CLASSIC

RW describes research done to design the American Modern line of dinnerware. Excerpted from slide presentation by Russel Wright, "Development of American Modern Dinnerware," 1959.

Opposite: American Modern water pitcher, the most widely recognized RW design, shown in the ten colors produced. Back row: black chutney, cedar green, glacier blue, cantaloupe. Center row: chartreuse, bean brown, white. Front row: coral, granite gray, seafoam.

I thought and theorized a long time about the serving of food and thus I decided that there must be two basic considerations in designing for food services: First, the design should form a background for the food to be eaten, visually flattering the food; secondly, the design should establish a mood for the meal. I believe that the first aim was subject to close and limiting specifications, that the second had infinite variety, but it needed guidelines to keep it from wrecking the first purpose, that of visually flattering the food.

Of course, I first studied the materials to be used for the containers of food, deciding such things as that glass was best for cold liquids, pottery or plastic for the insulation of warm liquids, and so forth. Then I went on to establish criteria for flatware and cutlery, for tabletops, for napery, for lighting, for seating, and for the walls and floors of the dining area. As the winetasters had devised the

shapes of glassware for various wines, I set up for every element of food service specifications that would satisfy a simon-pure academic gourmet to show off the food to its best advantage.

In considering the desirable general character of the shapes for dishware, I thought that since most foods are amorphous in shape that the dinnerware should be of simple geometric form yet without sharp angles which would attract more attention than the food, and I found that there should be no decorations on the surface, and thus I designed the American Modern line of dinnerware.

My photographic studies I think proved that the colors of food were shown off best against black and that in fact a complete black setting was the perfect answer to the simon-pure gourmet.

A middle shade of gray was a modification of the black in terms of showing off the true color values of food. I found that food against white made the food become opaque and that the reflection of the white dishes struck the eye before the colors of the food.

Brown was found to be good with food because brown contains all colors. I found that this brown glaze produced more calls for seconds than any dinnerware I use.

The rimless plate and the lack of decoration and the gray glaze were quite shocking and certainly were not immediately accepted. Sheila Hibben of the *New Yorker* magazine wrote viciously about the ware. Two pages of the *New Republic* ranted against it. I fought a small duel with Emily Post concerning the cup in the letters to the *New Yorker* magazine.

A successful sale led to my designing table linens, glassware and flatware to coordinate with American Modern. And hundreds of stores all over the country carried much advertising to promote American Modern tableware. Stories of its success can hardly be exaggerated. During the forties, arrivals of shipments at stores such as Gimbel's in N.Y. would cause near riots. Queues as much as two blocks long necessitated calling out the police. On one occasion two women were injured in pressing to get the wares, and were taken to the store Dispensary, and after being administered to, they got back into line. At Altman's in N.Y. twice the arrival of shipments was announced by banners stretched across Fifth Avenue at 34th St.

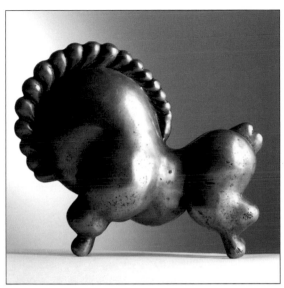

The start of RW's industrial design career. This horse bookend, produced in 1928, is one of a line of metal home accessory circus animals.
All color photographs in this portfolio by Masca.

PORTFOLIO

Streamlining was nearly a four letter word around 1940, but one industrial designer was well intentioned, well informed and rather deft; that was Russel Wright, of course. He cared for handicrafts, was not above learning from "Early American," could twist a chromium tube with the best of them and win hands down when it came to spinning aluminum, and he had a flair for free-form design as well.

—Edgar Kaufmann, Jr.,
Interiors, 1960

Left: Cocktail set.
Opposite: Clockwise from top—tidbit stand, ball vase, double boiler, lemonade pitcher, sherry pitcher, vegetable server, bun warmer, canapé tray, fruit basket, flowerpot, pasta pot with sauce and cheese containers, and two relish trays.

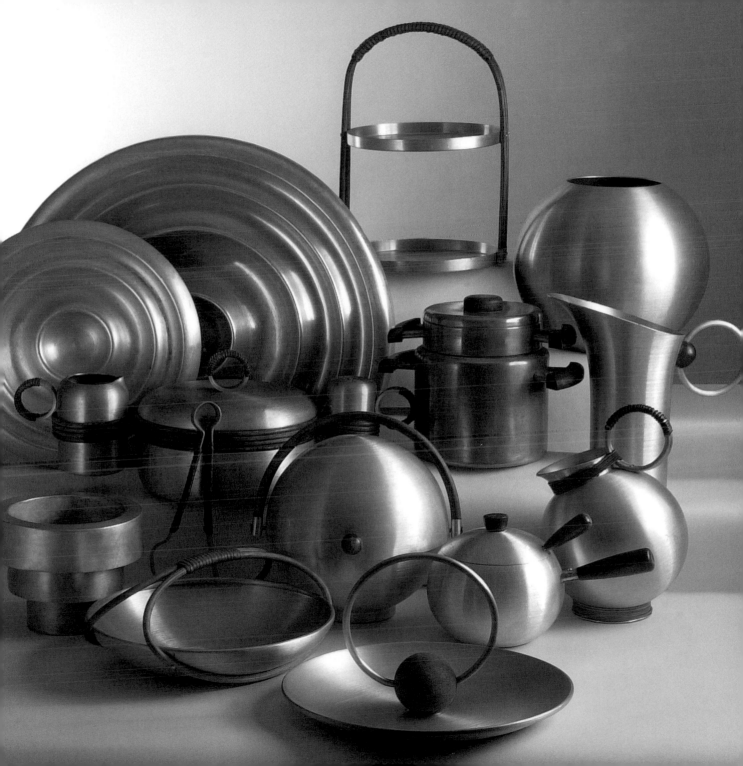

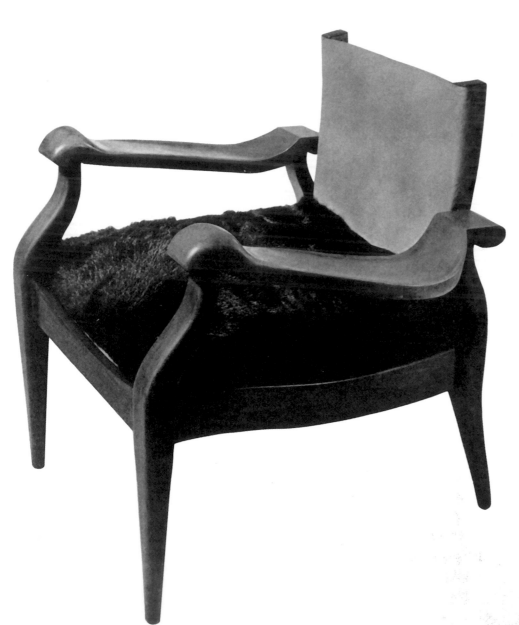

Left: Cowhide chair
once used in the
conference room at
the Museum of
Modern Art. It is in
MoMA's permanent
collection. Another
chair is in the
collection of the
Cooper-Hewitt,
National Design
Museum,
Smithsonian
Institution.
Opposite: Sterling
flatware designed
in 1933.
Reproduced in
silver plate in 1987
for the gift shop of
the Metropolitan
Museum of Art.

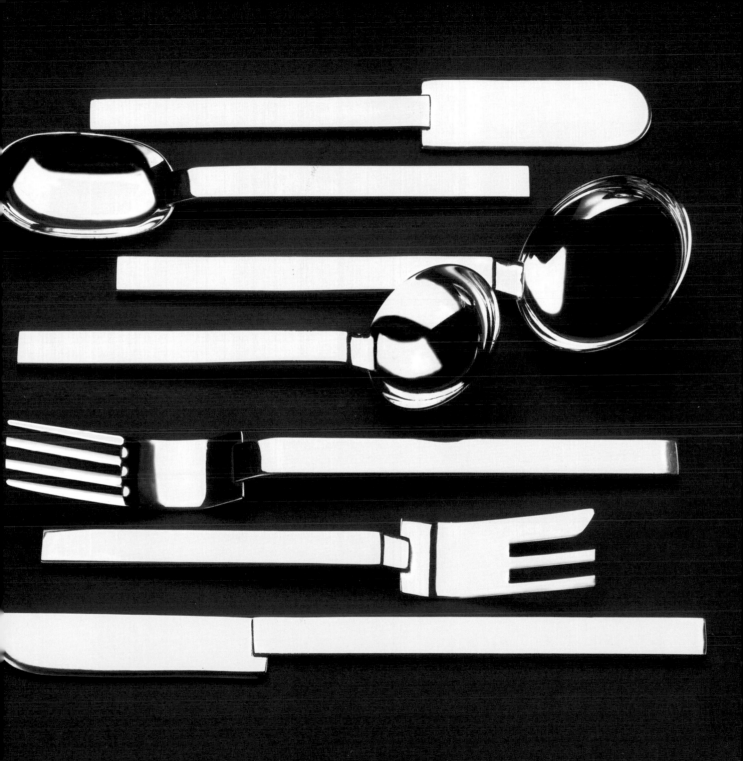

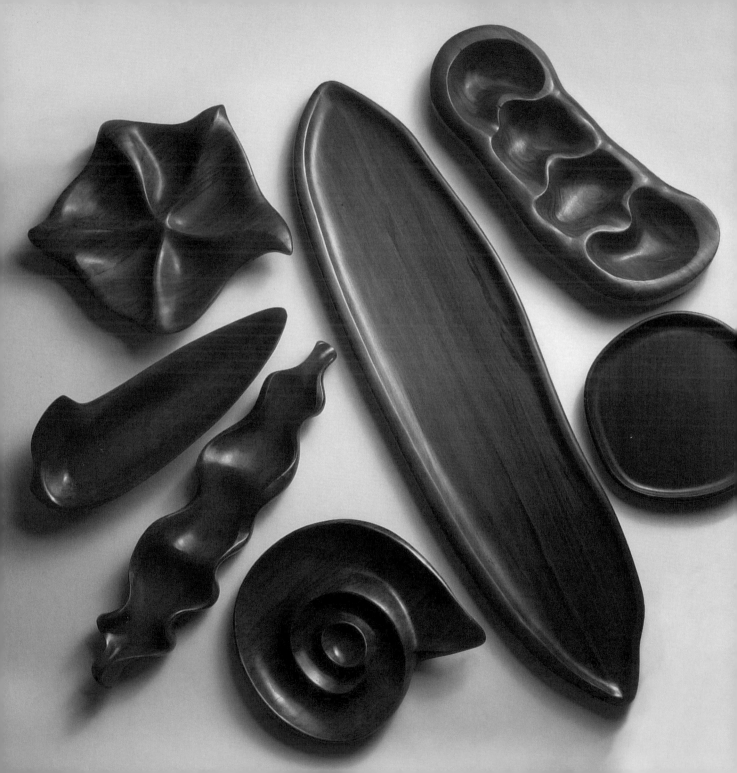

Right: Chrome and glass ice bucket and salad servers. Opposite: Examples of the Oceana line.

**Wright's work with wood evidences a reverential respect for that material, exemplified by the meticulous concern with which he selected various woods for accessory items using them in ways not common before.
—Ann Kerr,
Collector's Encyclopedia of Russel Wright, 1998**

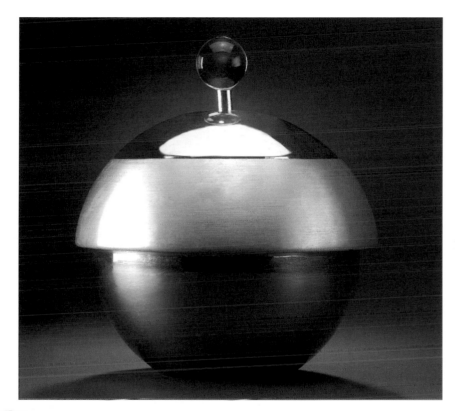

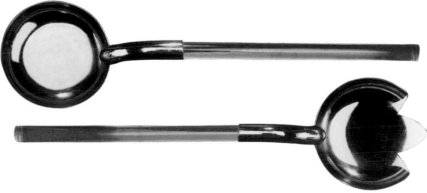

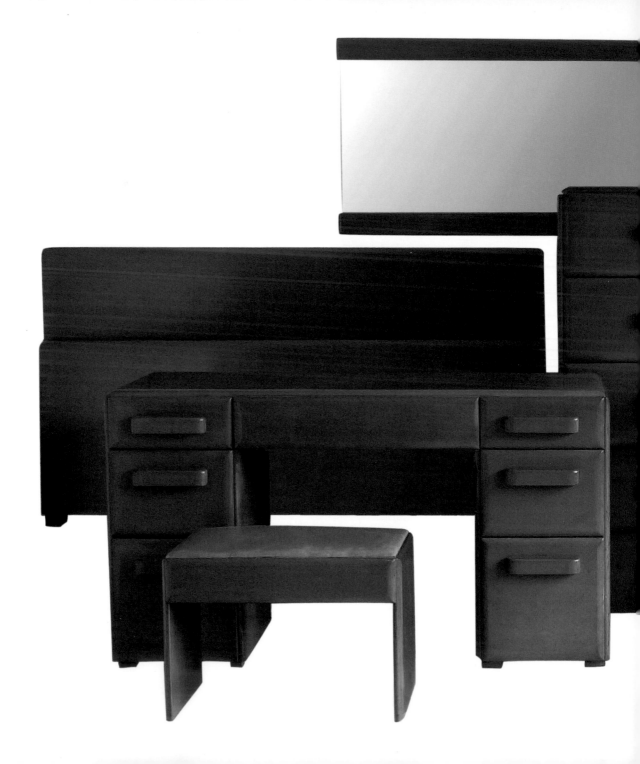

American Modern bedroom set in maple, 1935.

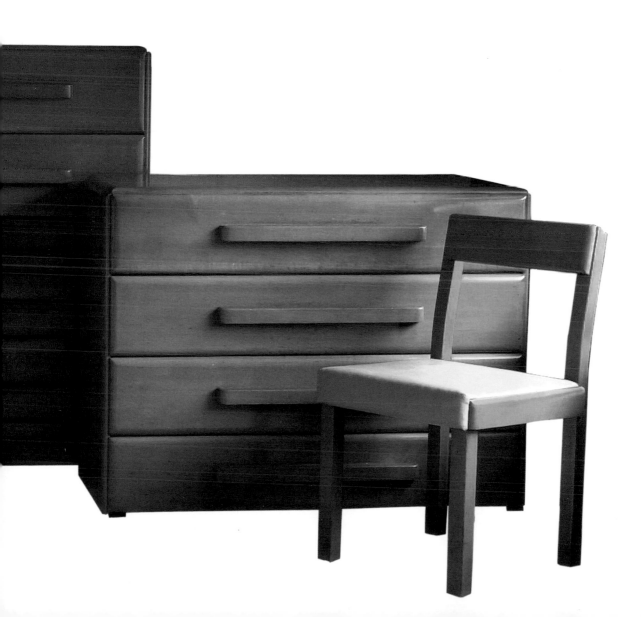

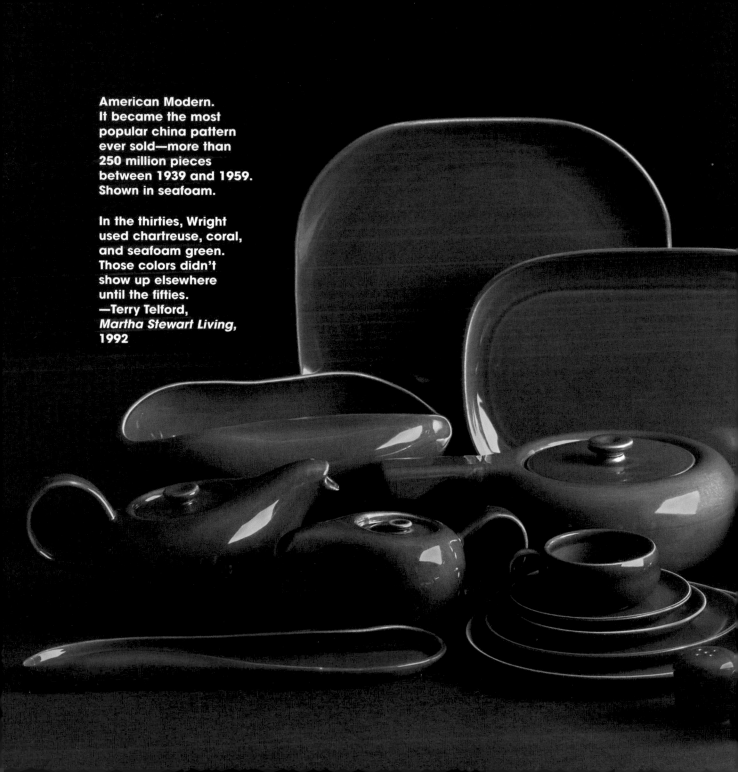

American Modern.
It became the most
popular china pattern
ever sold—more than
250 million pieces
between 1939 and 1959.
Shown in seafoam.

In the thirties, Wright
used chartreuse, coral,
and seafoam green.
Those colors didn't
show up elsewhere
until the fifties.
—Terry Telford,
Martha Stewart Living,
1992

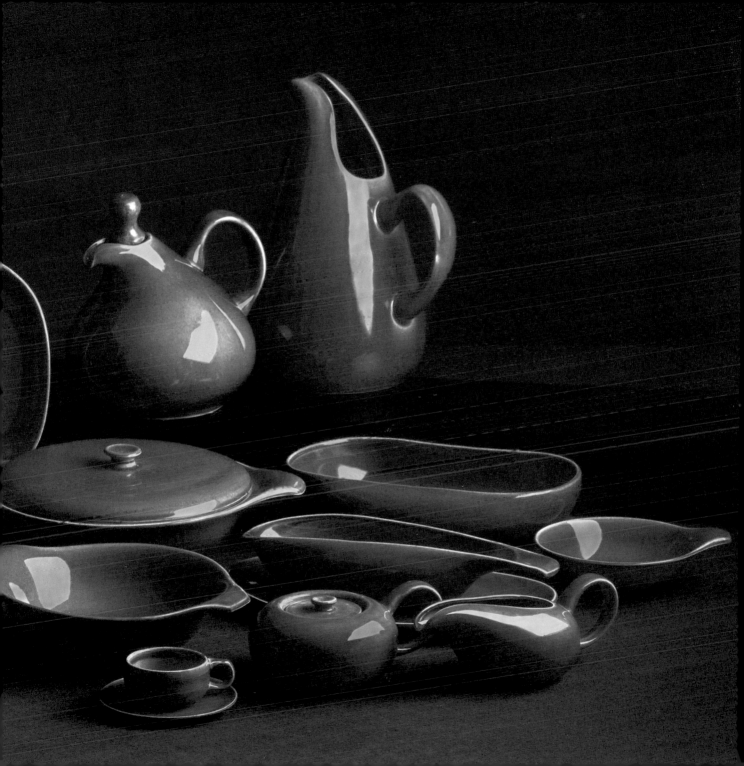

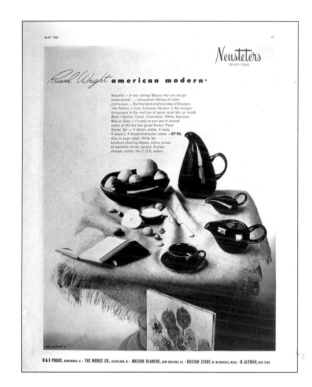
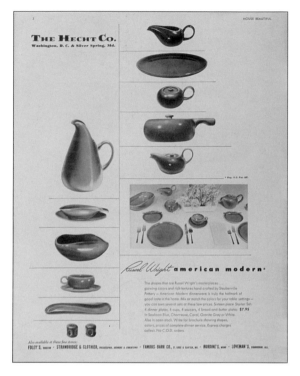

Above: Magazine advertisements.
Opposite: Bottom of plate showing RW signature. RW pioneered the marketing practice of combining name recognition with product design. His signature by contractual agreement was to be used on all advertising and products—a common practice today but not in RW's day. Rather than compromise the integrity of his name, RW refused many lucrative offers to place his signature on products that he did not design.

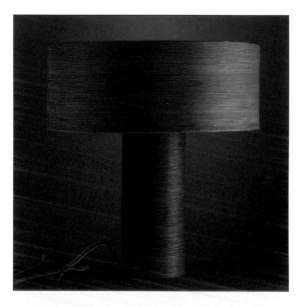

Russel Wright was the most responsible for the shift in taste toward modern in the late 1930's.
—George Nelson, *New York Times,* 1976

Wright's designs were refreshing, pared down, practical, and affordable, for the informal way he imagined American men and women wanted to live.
—Julia Johnson,
Martha Stewart Living, 1992

Clarity and simplicity were key to Wright's work, dignity without stuffiness.
—Russell Lynes, *Architectural Digest,* 1983

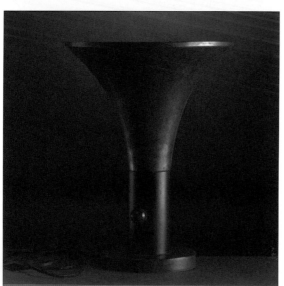

Wright's major achievement was that he made Americans aware of the need for beauty in daily life.
—Wolf Von Eckardt, *Time,* 1983

Before Russel Wright, American homemakers wouldn't buy American design.
—Barbara Flanagan,
Metropolitan Home, 1988

Wright was no elitist. He was very concerned with creating good design for the common man.
—William Straus,
Martha Stewart Living, 1992

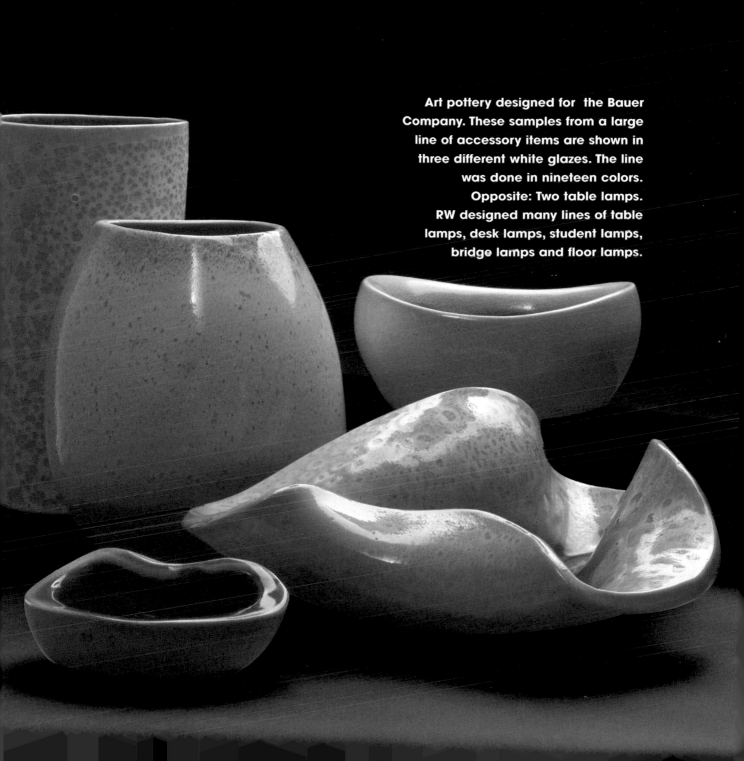

Art pottery designed for the Bauer Company. These samples from a large line of accessory items are shown in three different white glazes. The line was done in nineteen colors. Opposite: Two table lamps. RW designed many lines of table lamps, desk lamps, student lamps, bridge lamps and floor lamps.

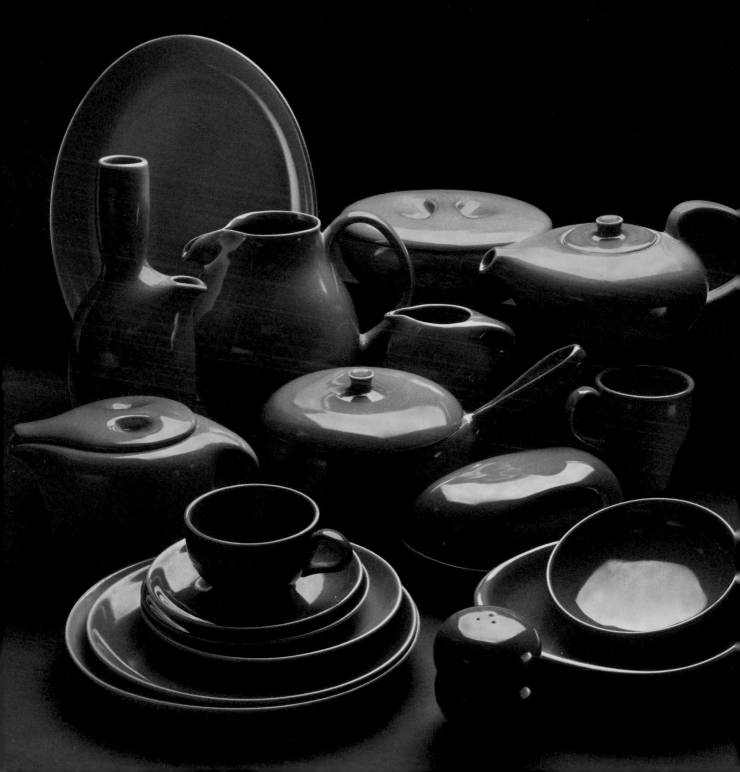

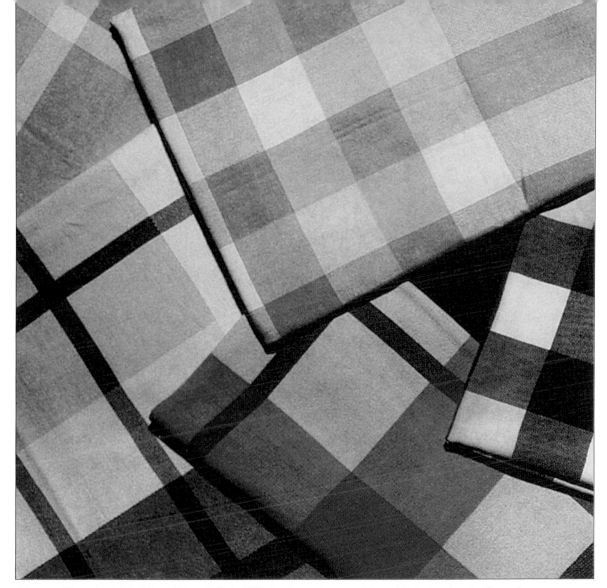

Above: Five plaid tablecloths, 1950. RW designed a variety of fabrics including drapery, carpets, upholstery, and placemats.
Opposite: Casual line of china, photographed in ripe apricot. It could also be bought in thirteen other colors: lemon yellow, avocado yellow, sugar white, lettuce green, oyster, pink sherbet, cantaloupe, nutmeg, ice blue, parsley, charcoal, aqua, and brick red.

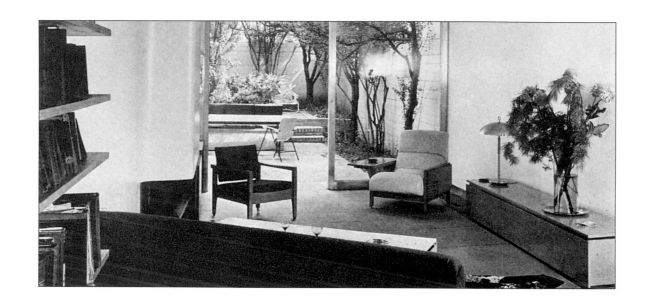

Easier Living furniture in RW's New York City townhouse, 1950.

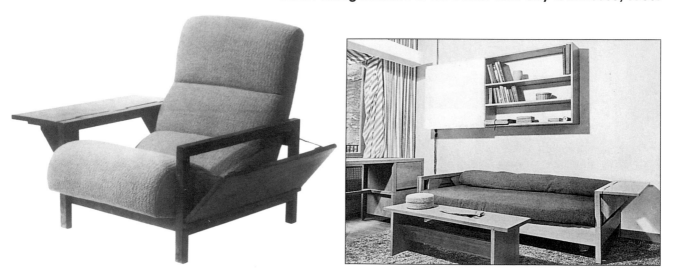

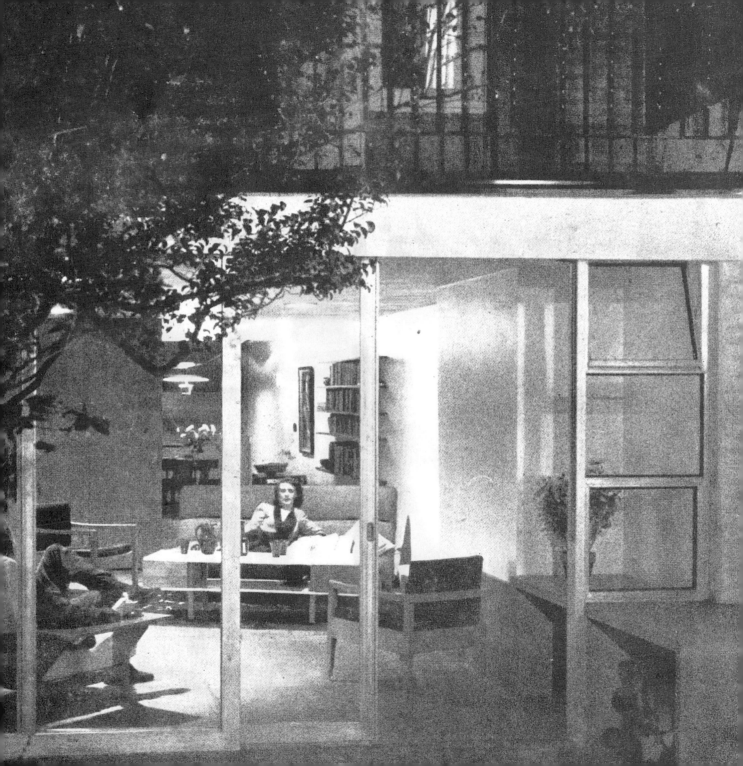

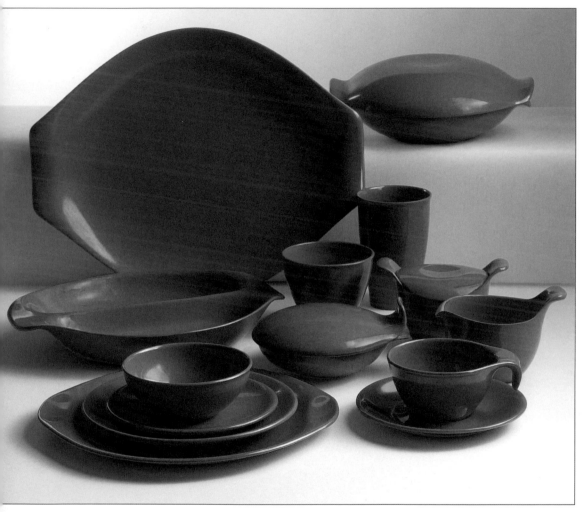

Residential line of plastic ware, photographed in salmon. Winner of the Museum of Modern Art's Good Design Award in 1953, it was the best-selling U.S. dinnerware in 1957. Residential could also be bought in seven other colors: sea mist, gray, lemon ice, black velvet, white, light blue, and copper penny. Opposite: Opaline glassware from Theme Formal dinnerware, RW's most formal line. Produced in Japan, Theme Formal combined porcelain, glass, and lacquerware.

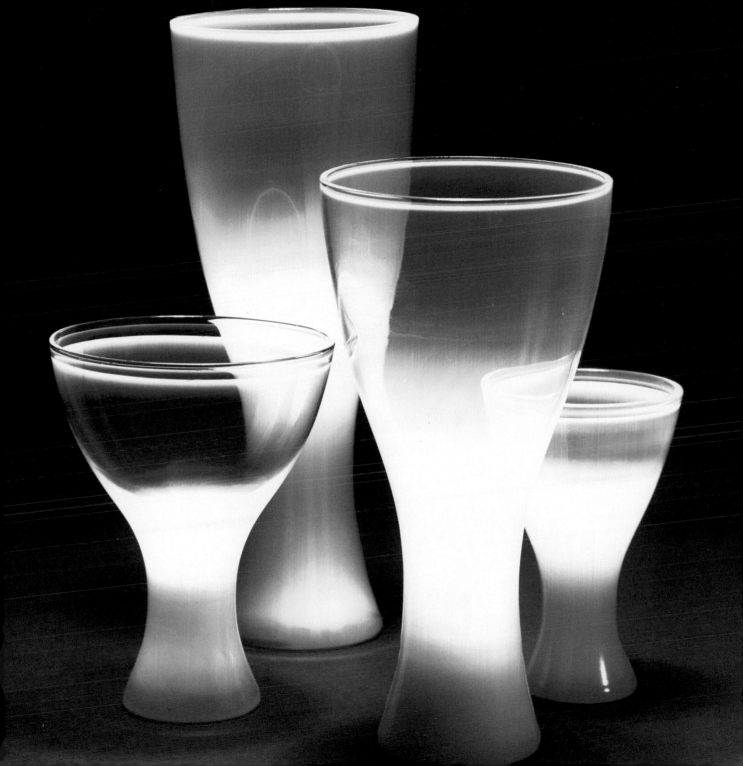

THE HARD WORK
OF INDUSTRIAL DESIGN

RW describes the industrial designer's work to a meeting of art educators. Excerpted from a talk by Russel Wright, " 'Mechanics of Magic' or 'Hard Work of Industrial Design' ", presented at the Philadelphia Art Alliance, March 23, 1938.

Industrial design is still such a young profession that manufacturers do not yet have sufficient understanding of the industrial designer's work to choose or use industrial designers intelligently. The manufacturers with whom I have worked seem to regard the industrial designer as a strange creature—a kind of magician who pulls rabbits out of a hat for them, a medicine man skilled in the art of some strange voodoo which will produce sales for them.

Perhaps the main secret is in the fact that an industrial designer is not merely a designer. In fact, a very small portion of him need be a designer. In my case, I have found that an average of not more than 10% of my time is spent in actual designing. The other 90% of my time is spent in doing things which the manufacturer who regards me as an artist has no idea that I do. In the first place, an industrial designer must know as much about business in general as possible and should have some specific knowledge about a great many different kinds of business which might use his services. Then, he must know something about merchandising in general and the merchandising of a great many different kinds of merchandise. He should know a good deal about advertising and the advertising methods used for many different kinds of products. Of course, it is obvious that he should know a lot about sales and selling tastes and the peculiarities of all kinds of customers, and then he has to know about the techniques of production; about materials and the different kinds of machines. All of this he has to know and have continual experience with, in addition to a talent for form, color, and line.

After finally ensnaring a client, our first interview is with him and his sales manager. The subject of this first conference is sales. We find out what his product or products are like at the present time before our designing work; which ones have sold best and which least; and what is more important, we try to find out why certain articles have sold better than others. We find out how many salesmen he has. How much of the country he covers. Which portion of the country gives him most sales and which portion least, and why. Who is his advertising agency. How much does he spend on advertising. How much of this is mail advertising and how much is space advertising. What method does he use in training his salesmen. If possible, we want to see as many of these salesmen as we can. Now salesmen, by reputation, are supposed to be of pretty low mentality. But I have found them very helpful. These are the people who will finally handle the selling of the designs you make. They can tell you a great deal about their buyers. They can point out to you the strange aversions which the trade has to certain types of styles that you would not realize otherwise. They can tell you exactly what difficulties they have had with the merchandise.

This first interview may take only an afternoon or a day. In some cases, however, it may take much longer. Sometimes, we have had the manufacturer get up for us sales records for over a period of years and we have taken these back to the office with us where we have studied them carefully in relation to actual photographs of the pieces which he has sold over the period of these years. This sort of study with actual figures has allowed us to classify the patterns into first, second, third, and worst sellers. And when we have finally completed this analysis, it is sometimes possible to deduct a decided trend and to know a great deal about the public's taste and the type of merchandise we are bound to design.

Our next procedure is to learn as much as possible about the manufacturer's method of producing his merchandise. For this purpose, a trip to the factory is best. At the factory we go through the complete works. We learn what kind of materials he uses and where they come from. What kind of machines he has and how the plant is laid out. We go through the entire set-up including the shipping and packing. Of course, this kind of investigation is the sort of thing that designs are made up of. It goes without saying that a knowledge of the manufacturer's method of producing will greatly affect your designs.

The trip to the factory is also important for another reason. That is a good-will journey. The factory people are naturally antagonistic to anyone from the outside. I try very hard on these trips to the factory to befriend the factory foremen. I find out what kind of drawings they need and listen to their troubles. This is important, because you find that so many people are incapable of reading blueprints executed in the usual architectural manner, and samples always seem to go wrong.

The next thing that we do is to make our market study. It is important during the market survey to try to determine whether or not there is any current style trend for the kind of merchandise that you are designing. A designer seldom, if ever, literally starts a new trend. The seeds of a new trend must be there. It is the industrial designer or the stylist's job to follow this trend in advance of the rest of the market and to anticipate it.

Now, we have passed through three stages of work: the sales conferences, the production study, the market survey. We still do not start our designing work.

The next thing that we do is to prepare a list of the merchandise that we are to work on. Along one column we place the retail prices of the articles that we are to design. We have procured information for these prices from our talks with the manufacturer and his sales manager and with the buyers and merchandising men. In certain cases, when we know that a certain item is needed for promotional purposes—the mark-up is naturally less than in the regular portion of the line. Then, next to these wholesale prices, we list the articles with a brief description of them. For instance, we indicate that certain numbers are to be prestige articles, certain numbers, bread and butter, and certain numbers, "Borax" (very inexpensive). These descriptions may be fairly general, or they may go so far as to describe how the articles will look, what sort of colors and finishes they will receive. This list takes a great deal of time and study, but it is imperative in doing a large line of merchandise, in order to get the proper balance of style and price. On the completion of this list, we take it to the sales manager and the manufacturer and get their criticisms. In some cases, we go over this list with his most friendly buyers.

Now you see how much time has been spent on these various procedures before attempting any designing. Designing is our next stage. In order to further facilitate our work, we have procured from the manufacturer photographs of his present line and have marked these photographs with the present retail and wholesale prices. After we have made our sketches we pick these up and compare them with our own designs. I ask myself, "Does my sketch contain any more material, any more difficult constructions, any more work in constructing, and any more external finish?" If it contains more of all these things, I must try more designs or simplify my present sketches. During this procedure, if we are in doubt about any construction, we make up construction drawings of small details and rush them by special delivery to the factory foremen, asking them if they feel that this new construction will be too difficult for production.

**Russel Wright set standards against which all modern designers have had to measure themselves.
—Henry Geldzahler, *Curator of 20th-Century Art, Metropolitan Museum of Art, 1976***

After a certain amount of time is spent in designing, the best looking sketches are chosen and sorted according to their practicability. The final selection is rendered in colored drawings. These receive the criticism of the manufacturer and may be altered. Finally, construction drawings are made up along the lines that the factory people like and sent to them for construction. The next stage, of course, is to criticize the models. In seeing the models, we always require that the manufacturer have them costed up in advance. We criticize their construction from the standpoint of the drawings that we sent to the factory. We carefully consider their proportions and make alterations, but most of the time is spent on comparing the costs with the desired figures. If a design is way off, we may have to completely re-design it. If the design is fairly close to our price, we try to simplify the design and we ask the manufacturer to take slightly less mark-up on this article and add it to another article in the line.

Now that the designs are manufactured and ready for production, our work does not cease. There are any number of duties which we may still perform for our clients, depending on our contract. One of the most important of these is to get together with the salesmen in order to explain to them the reasons for the designs, to discuss with them the exact balance of the merchandise as to price and style; a sort of pep talk that will get the merchandise started on selling. Then we will probably supervise the taking of publicity and advertising photographs.

Industrial designers are called upon to do so many different kinds of jobs that the entire theory of research and study before the designing work is of tremendous importance. Without this approach it would be very hard to adjust yourself from designing table accessories to designing printing machines, and then from printing machines to window displays, etc.

It is possible that this resume of the industrial design profession may seem grim to you—and perhaps the game not worth the candle. I must confess it often does to me. But uncover any profession and there is always more game than candle. What I have undoubtedly left out of this resume are the compensatory moments—those rare times of deep satisfaction when we know we have done good work.

LIST OF SELECTED DESIGNS

The wide range of RW's design interests is evident from this list of products, interiors, and machines, spanning more than 30 years of work in materials ranging from ceramics and glass to fabrics and wood. Adapted from William J. Hennessey, Russel Wright, American Designer, *Gallery Association of New York State (Cambridge: The MIT Press, 1983), pp. 91–95.*

APPLIANCES

1932	Radios	Wurlitzer
1942	Alcohol stove and coffeemaker	Silex Corp.
1947	Commercial popcorn warmer	Lodge Electric, Boston, Mass.
1953	Ceramic-faced clock	General Electric
1955	Broil Quick	Peerless Electric, New York
1958–61	Electro-thermal serving trays	Cornwall Corp., Boston, Mass.

DINNERWARE - CERAMIC

1937	American Modern line (marketed until ca. 1959)	Steubenville Pottery, East Liverpool, Oh.
1946	Casual China line	Iroquois China Co., Syracuse, N.Y.
1948	Vitreous hotel china	Sterling China Co.
1951	Highlight combined ceramic and glass line	Paden City Pottery, Paden City, W.Va.
1951	White Clover line	Harker Pottery Co., East Liverpool, Oh.
1956	Esquire Collection	Edwin M. Knowles Pottery Co., East Liverpool, Oh.
1965	Theme dinnerware	Schmidt International (Yamato Porcelain Co., Tajmi, Japan)

DINNERWARE - PAPER

1950	Paper plates and cups	Bowes Industries, Chicago, Ill.
1959	Paper plates, etc.	Sutherland Paper

DINNERWARE - PLASTIC

1945	Prototype set of Melamine dinnerware	American Cyanamid, New York City
1949	Meladur (commercial production of American Cyanamid designs)	General American Transportation
1953	Residential line	Northern Industrial Chemical, Boston, Mass.
1959	Flair line	
1955	Idealware polyethylene	Ideal Toy Co.

FABRICS AND FLOOR COVERINGS

1934	Carpets for Heywood-Wakefield line	Art Loom Carpets, Philadelphia, Pa.
1951	Carpets	
1951	Drapery fabric	Everfast Fabrics, New York
1951	Upholstery fabric for Statton line	Lumite Division, Chicopee Manufacturing, New York
1952–57	Fabrics	Foster Textile Mills, Chicago, Ill.
1954–55	Fabrics	Edson, Inc., New York

| 1954–57 | Fabrilite vinyl upholstery colors | Dupont, Wilmington, Del. |
| 1957 | Tile | American Olean Tile, New York |

FLATWARE

1933	Experimental silver flatware	Wright Accessories, New York City
1946	Stainless flatware with plastic handles	Englishtown Cutlery, New York and New Jersey
1951	American Modern line	John Hull Cutlery
1953	Highlight line	
1950–58	Cutlery designs made in Japan	

FURNITURE

1932	Cowhide chair	Custom
1933–34	Upholstered furniture line	Heywood-Wakefield Co., Gardner, Mass.
1935	Modern Living line (later called American Modern line)	Conant Ball Co., Gardner, Mass.
1936	Blonde Modern line	
1940	Old Hickory line	American Hickory Co., Indiana
1940	American Way line	Monitor and Sprague & Carleton Companies
1942	Knockdown line	Sears Roebuck, Chicago, Ill.
1945	Folding metal furniture	Colgate Aircraft Corp., Amityville, N.Y.
1950	Easier Living line	Statton Furniture Co., Hagerstown, Md.
1950	Samsonite folding metal chairs and tables	Shwayder Corp., Denver and Detroit
1955	School furniture	
1955	Folding metal furniture	Featherweight Aluminum Products, Montreal, Canada

GLASS

1945	Glassware set	Century Metalcraft, New York
1946–48	Various glass pieces	Fostoria Glass, Moundsville, W. Va.
1946–52	Bent glass serving pieces	Appleman Art Glass, North Hackensack, N.J.
1947	Uncolored glassware line	American Crystal, Washington, Pa.
1949	Flair line of tumblers	Imperial Glass
1951	Pinch line to accompany Casual China	
1951	American Modern glasses	Morgantown Glass Guild
1957–58	Stencil designs	Bartlett Collins Glass Co., Sapulpa, Okla.
1965	Theme Formal and Informal	Yamato, Japan

HOLLOWARE AND HOME ACCESSORIES

1928–35	Designs in pewter, chrome, and aluminum	Wright Accessories/Raymor, New York City
1935	Oceana line of free-form wooden serving pieces	Klise Woodenware, Grand Rapids, Mich.
1930s–1944	Corn set, ice buckets, beer pitcher	Chase Brass, New York
1940–44	Aluminum bowls, trays, ice buckets, etc.	Century Metalcraft, New York
1946	Freeform "art" ceramics	Bauer Pottery, Atlanta, Ga.
1946–48	Stove-to-Table line	Aluminum Goods Manufacturing Co., Manitowoc, Wisc.
1955	Aluminum and pewter pieces: ice buckets, trays, chafing dishes, thermos bottles	Ravensware, Brooklyn, N.Y.
1964–65	Plastic trays, buckets, colanders, etc.	Duraware Corp., New York

INTERIORS

1932	Redesign of street floor	Gimbel Brothers, New York City
1932	Showroom	Wright Accessories, New York City
1933	Cocktail lounge	Restaurant du Relle, New York City
1935	Office interior	George Bijur Office, New York
1936	Showroom	Wilkes-Barre Lace Co., New York
1939	Focal Food exhibit, Mental Hygiene exhibit Guinness Stout exhibit, Fashion Show, New York Department Stores exhibit	New York World's Fair, New York City
1944	Redesign of 4th floor	Saks, New York City
1950	Showroom	Statton Furniture Co., Grand Rapids, Mich.
1962	Self-service restaurant, prototype design	Brass Rail Restaurants, New York
1964	Restaurant interior	Shun Lee Dynasty, New York

LAMPS

1939–47	Miscellaneous lamps	Wright Accessories/Raymor, New York City
1946–49	Miscellaneous lamps	Acme Fluorescent, New York City
1949	Swivel lamp	Amplex Corp.
1951	Table and floor lamps	Fairmount Lamps, Philadelphia, Pa.

PACKAGING

1955	Calvert Reserve decanter	Calvert Distilling (Seagram)
1959	"Big Top Peanut Butter" jar and label	Procter & Gamble, Cincinnati, Oh.
1959–61	Catsup bottle and label	Hunt Foods, Fullerton, Calif.
1961	Bottle and label	Cresca, New York

TABLE ACCESSORIES

1946–48	American Modern table linen	Lecock and Co., New York
1946–48	Plastic tablecloths and mats	Cohen, Hall, Marx and Co., New York
1946–54	Plastic table mats	Hedwin Corp., Baltimore, Md.
1948–50	Napkins and table mats	Frank and Sadev, New York
1950	Plaid tablecloths	Simtex Mills, New York
1951	Vinyl table mats	Aristocrat Leather, New York
1951	Table linens and rugs	Patchogue Mills, New York
1951	Plastic table mats	Comprehensive Fabrics, New York

MACHINES AND MUSICAL INSTRUMENTS

Early 1930s	Linotype machine	Mergenthaler
1932	KRW piano, accordion	Wurlitzer
1933	Vending machine	Trimount

HOME

TRANSFORMING THE AMERICAN HOME

BY MALCOLM HOLZMAN, *FAIA*
Hardy Holzman Pfeiffer Associates

Russel Wright's mid-20th century designs transformed the appearance of the American home. His objects were exceedingly popular in their day, and they have become sought-after decorative arts items today. Most frequently, his objects were generated in large quantities for mass consumption, reaching every corner of the country. Occasionally, however, he designed singular items for testing the development possibilities for new visions.

Dragon Rock, his home and studio and the focus of RW's design energies for three decades, represents one of his few efforts that were intended to be unique. Sited on Manitoga's hilly woodland adjacent to an abandoned quarry, it was conceived as an experiment for total living. RW owned the property for more than a dozen years before starting construction of his residence and studio, providing ample opportunity to contemplate the terrain and examine the vegetation. When ready to build, he knew every inch of the land: the hillsides, trees, paths, potential views, the quarry, and where the sun and moon rose and set through the year. RW selected the intersection of the north side of the quarry and a hillside because it combined the two most dynamic elements, one made by hand decades earlier, and the other shaped by natural forces over centuries. This location drew plentiful sunlight that could animate the architecture and enrich the landscape.

RW was fascinated by certain topics for his entire career, returning to them many times in his creations. The knowledge gained from making domestic objects

can be perceived and appreciated at Dragon Rock. Here, he enlivened edges, dramatized openings, and selected colors for contrast or compatibility in a manner similar to designing an exceptional vessel. He was able to explore these concepts at a scale that was not possible in his other undertakings. His artistry was enhanced by the challenges of building with stone and timber, accentuating vistas, and bringing the manmade and natural environments together.

Even half a century after Dragon Rock's conception, these themes are still abundantly evident: RW chose not to obliterate the junction between the quarry and the hillside but straddle it to encapsulate this special edge in the main spaces of the house—the living and dining areas. The south-facing glass surfaces serve as an environmental screen that provides shelter from inclement weather yet still allows the enclosed spaces to be part of the exterior. The flagstone flooring extends beyond the house to form a terrace, while the granite wall containing the fireplace connects with the stones at the bottom of the large cliff. RW takes unusual care with the masonry to insure that the patterns are compatible with, but different from, the naturally formed stone surrounding the house. The use of trees throughout the house, including the uncut cedar trunk supporting the main roof and the evergreen needles imbedded in paint surfaces, ties the structure to the site.

RW had a penchant for combining colors, shaping surfaces, precisely defining angles, developing forms, and making lively edges. His curiosity about these topics appears in the design of many different objects: cups, pitchers, bowls, and plates. Testament to his success is the fact that these items, crafted as investigations in RW's individualized style, are now collectors' treasures. But only at Dragon Rock—conceived and constructed to optimize his typical expressive manner—was RW ultimately able to synthesize his design interests into one combining the manmade and natural environments.

Malcolm Holzman is founding partner, Hardy Holzman Pfeiffer Associates, in New York City. He has designed notable public buildings in twenty-five states; held endowed chairs of architecture at several universities, including Yale and the University of Texas; and received numerous awards from the American Institute of Architects, Pratt Institute, and Tau Sigma Delta, among others.

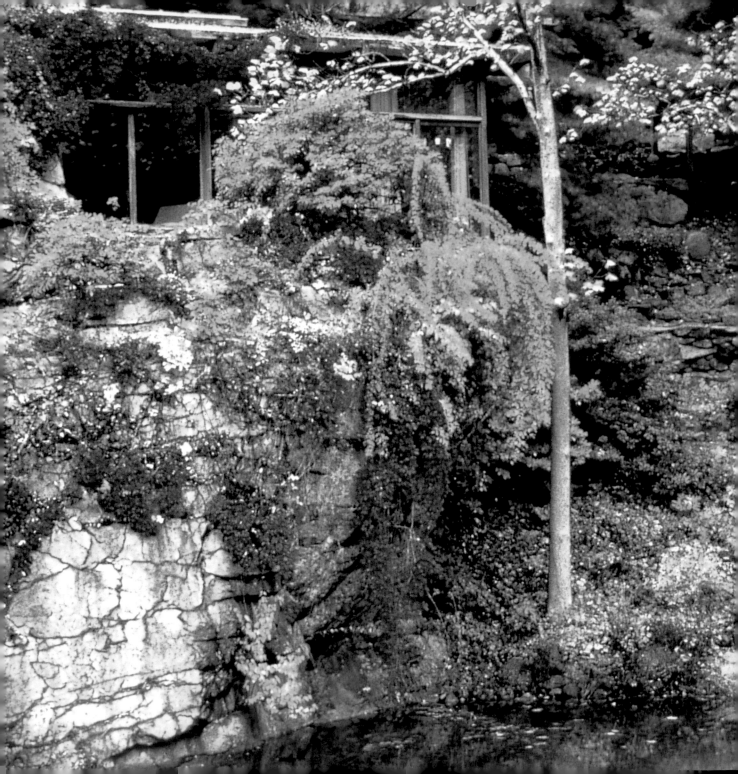

THE HOME
AS PERSONAL STATEMENT

RW explains why he created his Manitoga residence and studio.
Excerpted from Russel Wright, "Garrison Slide Lecture, April 1961."

As the assembly line encroaches more and more on our working life, crowding out individual creative expression, the need for a home in which we can realize ourselves as individuals becomes increasingly urgent.

My own experimental and personal country home is intended as an experiment and demonstration that contemporary design can create from old and new materials a home highly individual, capable of the variety of moods that can be found in traditional homes, a home that can join the emotional, sentimental and esthetic characteristics with the practicality and comfort that we have created in the 20th century.

I have planned and labored hard and long, at so much expense of money and energy, that I certainly am not recommending anything comparable to anyone else. Dragon Rock, the house in Garrison, must not be thought of as a prototype—it is an exaggerated demonstration of how individual a house can be. I have been pleased to overhear some visitors to the new house say that they wouldn't live in the house even if they were paid to do so.

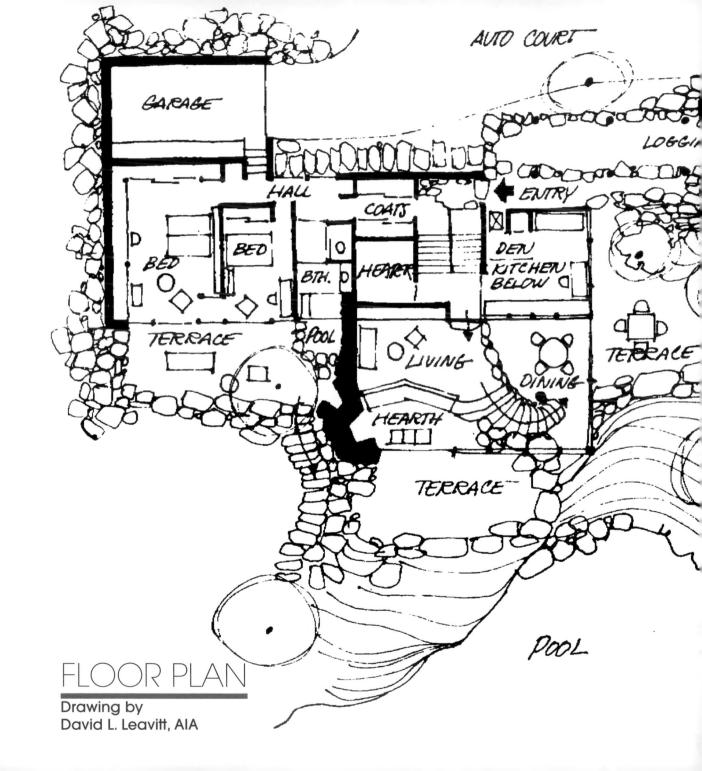

AUTO COURT

LOGGI

GARAGE

ENTRY

HALL

COATS

DEN
KITCHEN
BELOW

BED

BED

HEARTH

BTH.

S.POOL

LIVING

TERRACE

DINING

TERRACE

HEARTH

TERRACE

POOL

FLOOR PLAN
Drawing by
David L. Leavitt, AIA

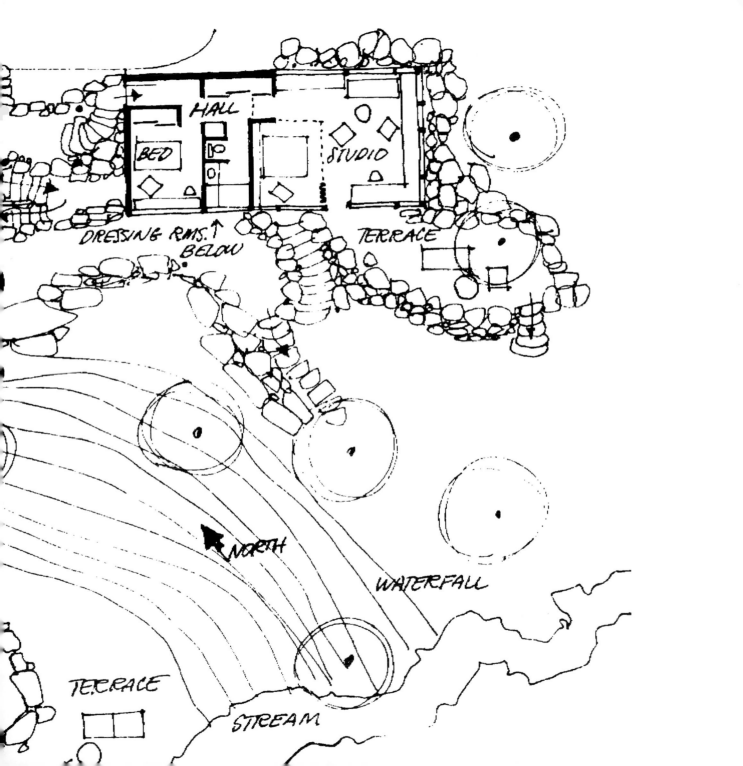

HALL

BED

STUDIO

DRESSING RMS. ↑
BELOW

TERRACE

NORTH

WATERFALL

TERRACE

STREAM

PHILOSOPHY OF THE HOUSE

RW discusses the aesthetic and design principles of Dragon Rock in the draft of an essay addressed to those involved in building the house. This is the oldest surviving account of how RW understood the house as a design project. To provide a fuller sense of what Wright was trying to convey, we have added text in brackets from a later version. Russel Wright, "Philosophy of the House at Garrison," ca. 1958.

It would be good for all those who assist me in the building of the house at Garrison in any way to have some knowledge of its meaning to me and of what I believe the aims should be. Herewith is an attempt to set forth my targets of attainment and to explain my design.

The aims: First, the wedding of the house to the surrounding land. These surroundings are certainly unusually beautiful. I think it is one of the most interesting bits of land that I have seen anywhere in the world.

Therefore, the designing and the making of the house is a challenge because the house should complement this tiny bit of the world. We should all try to preserve its beauty and be careful not to injure or to desecrate it. More than this, we wish to demonstrate and enhance its unusual beauty and charm.

Expression of the particular use to which the house shall be put is important. The house is to be occupied by me and my daughter, both of whom have a great love of nature. While in it, we want to express our love of this land. We want it to service our need for rest and revitalization from the hard work and sophisti-

cation of New York. Not only our emotional needs, but our physical 20th century needs of a great degree of physical comfort, must be satisfied here.

I will try to say in a few words the theme for my designing of the house: Here I found on the side of the mountain the cavity made in the rocks by an old Early American quarry. I turned the course slightly of the mountain stream to fill it up, making a beautiful waterfall and swimming pool, walled by silent gray cliffs and green hemlocks. Round about the quarry are found thousands of huge boulders untouched and magnificent in shape and color; and thousands of huge stones that have been partially cut by men years ago in their work at the quarry.

In a corner of this aging quarry, I would like to create a shelter in which I can live comfortably and still enjoy the beauty of this land, the surrounding woods, the stones, the sky, the river, the animals. But I do not want this house to dominate the land. The shape of the quarry and the surrounding contours of the land and the rocks must always be visually the most important part of this scene. I love it so much that I wish this shelter to blend with the landscape and be an unshocking contrast with it. Therefore, I will make it of the rock to be found there, of the lumber to be found there; and I will cover it with vines that are native.

Masonry—It is impossible to say what is the most beautiful part of this bit of the hill, but its most distinctive characteristic is the rock, the gray granite of the quarry pit itself, and the surrounding boulders. The curving of the cliff walls is so noble that we must be careful of everything we do in the use of stone for the construction of the house.

Manmade patterns of masonry would only suffer by comparison. Therefore, I have decided that I will not use any of the established, traditional patterns of masonry anywhere in the house or in its surroundings. Our masonry work will be an experiment—an interesting design experiment because we wish to evolve in the necessary masonry of the house a pattern of design which will subtly point out the great beauty of the natural cliffs. If we are successful, this may well be one of the most interesting elements of the house itself.

In evolving our design of the masonry to fit this particular house, my suggestions are these:

1. Study the sculptural groupings of the natural untouched boulders about the land. These are to be seen particularly on the upper rim of the quarry.

2. Study the large cut stone piles—one such pile is at the base of the tallest cliff. They have been left by the quarry makers. The weight of the stone cliffs (fell) by gravity to form a strong mass without the use of mortar or of the work of laying the stone.

Between these two groups, I deduct that we must never use a geometrically cut stone, or a geometrical pattern of laying the stone, in the making of masonry to support the house. Therefore, at the support of the garage wall, I have laid the boulders to simulate the piles of natural un-cut boulders to be found on the land. Therefore, in the planning of the wall which holds the fireplace for the living room, I will attempt to reproduce the effect of the stones piled at the bottom of the large cliff.

Contrasts—The house must express the idea of the combination of the comfortable living that is necessary to the New Yorker as well as his emotional need for the country and for nature. Therefore, it is expected that there will be CONTRASTS as well as BLENDS.

Blends—There will be occasional blends to bring the outdoors gradually in; for instance, blends occur at the lower part of the living room with a flagstone terrace and which will continue from the outside to the inside. This occurs again in the dining room and at the upper level of the front entrance.

Contrasts—On the other hand, the geometric regular rectangularity of the design of the house would contrast with the amorphic character of the land formation and the highly textured irregularity of nature's growth.

Inside the house, the rectangular windows with a clean geometric line will contrast and frame the designs of nature that appear through them. Large expanses of machine-made materials, such as vinyl, fiberglass, etc., will dramatically set off the pieces of nature that will be brought in as contrast to be visually shocking. Nature will be brought in for these "shocks" or "contrasts" in various ways. For instance, the use of the uncut cedar tree as the main post supporting the ceiling of the whole large house; the pile of boulders in the living room; the boulder

in Ann's sunken bathtub; the use of delicate limbed trees to hold towels in the bathrooms; the use of a log as a seat at the entrance; the use of a section of the log as the windowsill in one of the hallways of the main house.

Color—The interior color scheme of the house will be planned so that it can change, summer and winter. Here again, the idea of *contrast* and *blend* is used. In the summer, the color scheme will be cool and analogous with the green of outdoors—a *blend.*

In the winter, there will be *contrast,* because the draperies indoors will change to a warm color scheme.

(Here are a few examples: The dining room "draperies" in winter will be ribbons in three shades of red; and in summer five shades of white yarn. The panel on the balcony above the dining room will be bronze sheet metal in winter, and flip to a composition of white film and fiberglass in summer. The cabinet doors in the living room and dining room are double faced and in winter are Indian red lacquer reversed to white formica in the summer. The living room built-in sofa wears a red textured cotton fabric slipcover in the winter, with brown and red pillows, and in summer the slip cover comes off to reveal a white leather cover, with blue and white pillows. The living room rug in the winter is a colorful khilim, and in summer is replaced with a sisal rug. The white sheepskin slipcovers on two Danish teak chairs come off in summer to reveal the blue upholstery. In the mezzanine area the sliding plastic panel by the bookcase reverses from autumn leaves on a dark background in winter to summer grasses on a white background in summer. Accessories and objects will change with the seasons. For instance, in the living room a square Chinese embroidery in blues, lilac and mulberry is replaced by Audubon owls in the winter.)

The theme of the house is to minimize the distinction between the inside and the outside. To be in it is to be in the landscape, to experience snowfall and rain, morning sun, drifting leaves. . . the ever-changing vitality of the seasons.
—Carlton B. Lees, *Senior Vice President, New York Botanical Garden, 1981*

This is a design project I am most pleased with, more than any other project throughout my career.

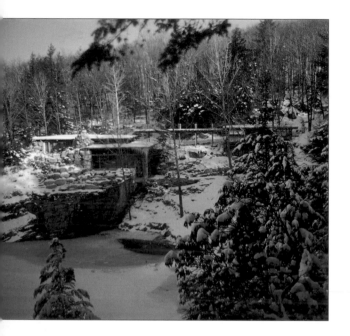

The photographs in this portfolio show **Dragon Rock** as it was when RW lived there. RW located his home and studio on the edge of an abandoned stone quarry. He diverted a stream to make a waterfall and fill the quarry with water.
Overleaf: Entrance to house seen from the parking court. RW intentionally hid a dramatic view of the waterfall and quarry pond behind Dutchman's pipe vine on the trellis, to create a surprise as visitors reached the front entrance.

PORTFOLIO

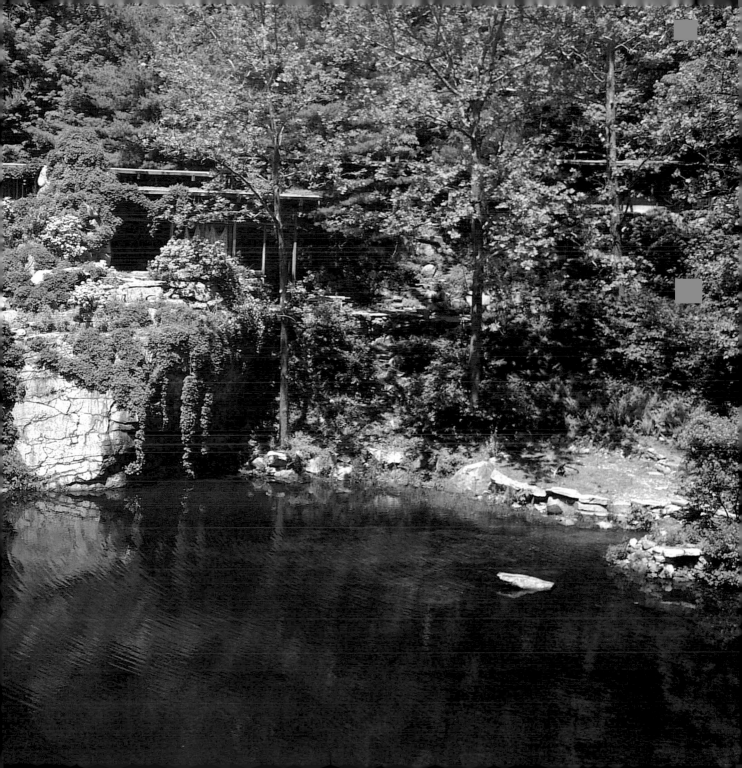

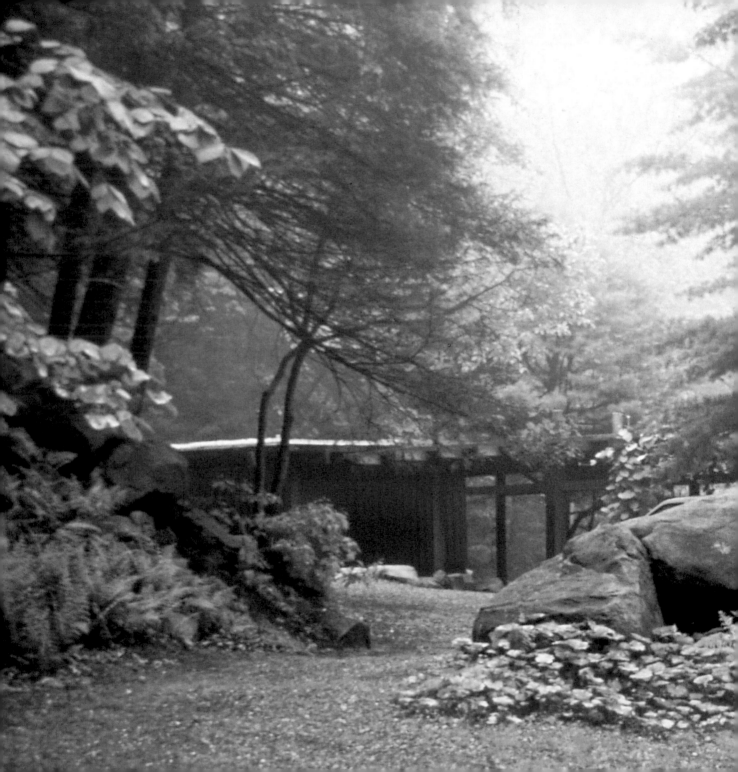

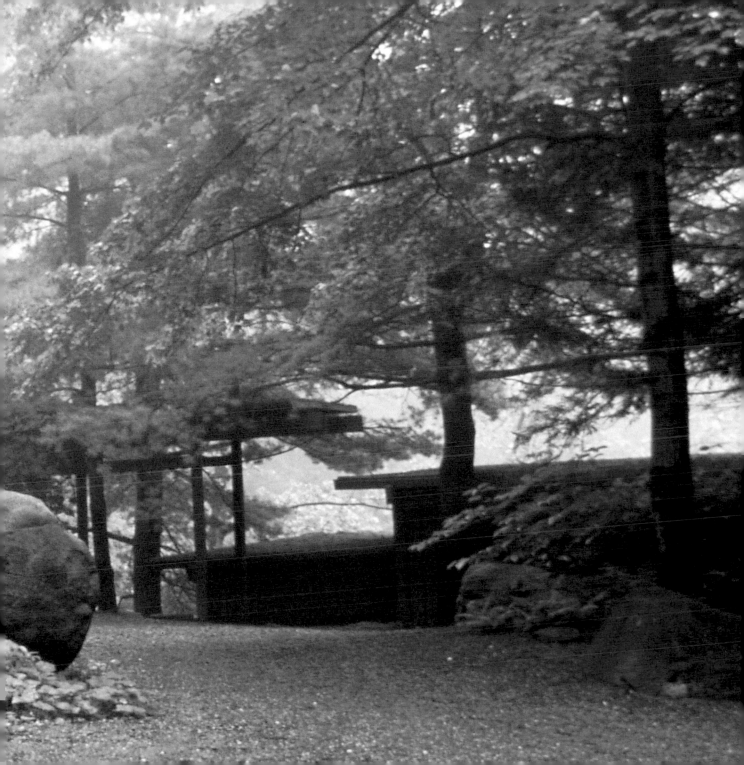

Left: Detail of living room wall. Evergreen needles pressed into the plaster, which was colored the green of hemlocks across the pond, evoke the outdoors.
Right: The living room changes from cool colors and fabrics in summer to warm ones in winter.

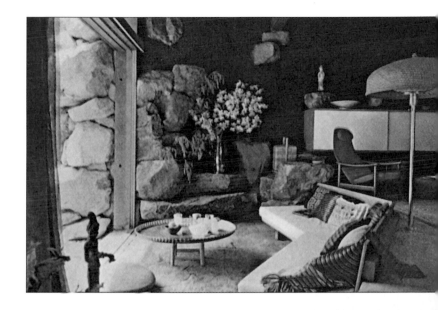

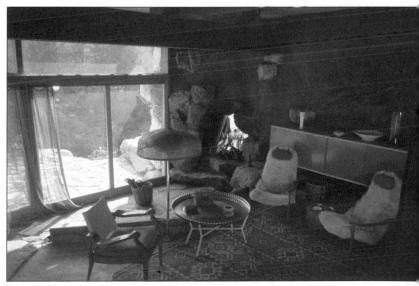

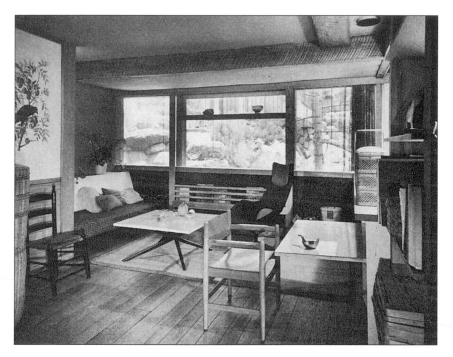

Above: Den-mezzanine in summer.
Opposite: RW in the den-mezzanine in winter.
Among the seasonal changes, the Audubon
reproduction is a wild turkey in winter, a black
crow in an apple tree in summer. The day bed
changes from a green cover in summer to a
brown one in winter. The rug is a tatami with
moss green binding in summer and a long
wool shag of warm colors in winter. Curtains
are made of brass fireplace screening. The
table in the center, designed by RW, and
shown at cocktail table height, can be raised
to dining height.
Right: Corner of den-mezzanine in winter.
Overleaf: Detail of panels showing both
sides—summer grasses and autumn leaves.

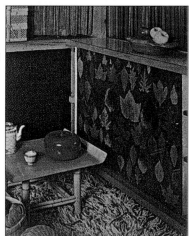

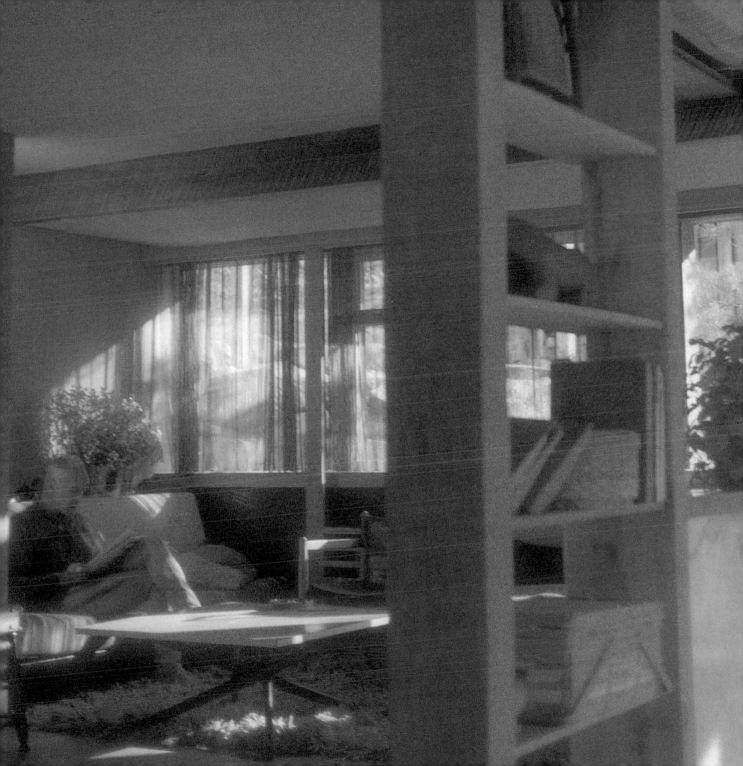

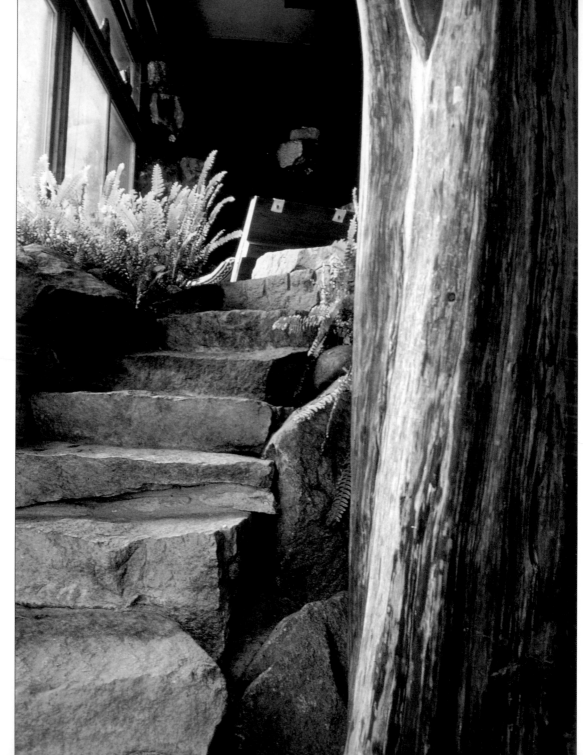

Right: Stone steps from living room to dining area. The cedar tree on the right is the main roof support. Opposite: Steps from front entrance level to den-mezzanine and then to kitchen level.

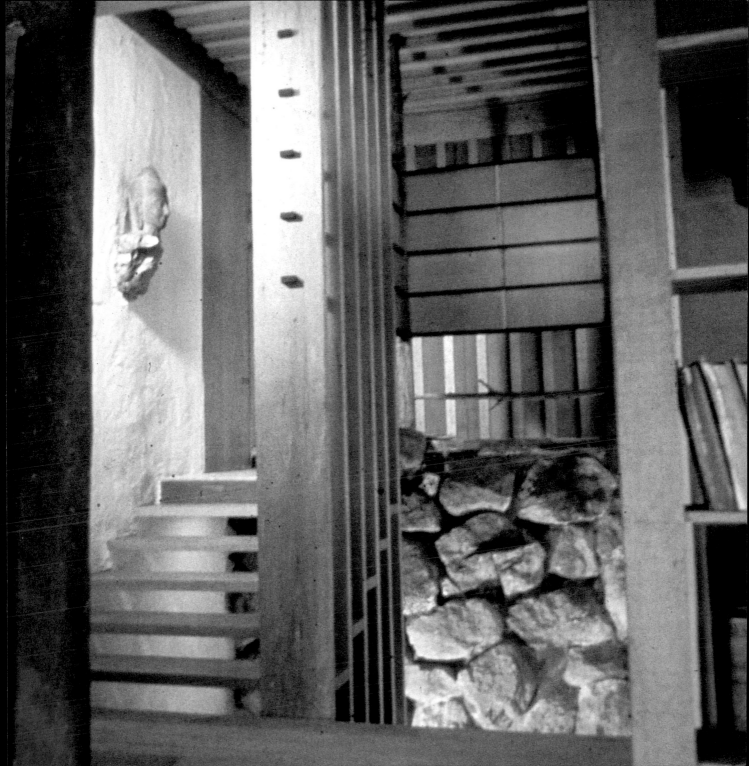

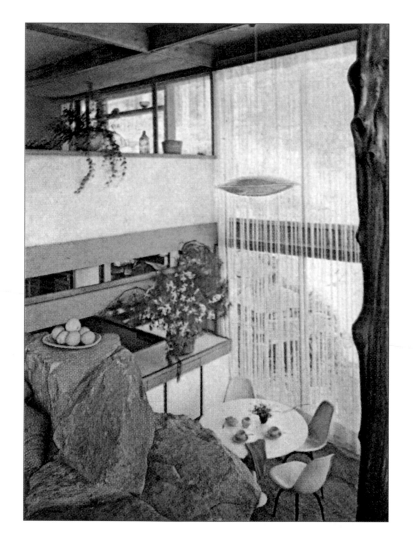

Seasonal changes in the dining area. Curtains are five shades of white yarn in summer and three of red ribbon in winter. The summer chandelier, a plastic globe filled with small lights, is replaced in winter by a wrought iron chandelier with candles. White formica cupboard doors below the pass-through reverse to red lacquered wood in winter. The panel on the den-mezzanine reverses from white fiberglass in summer to bronze sheet metal in winter. Table linens and pottery also change for the seasons.

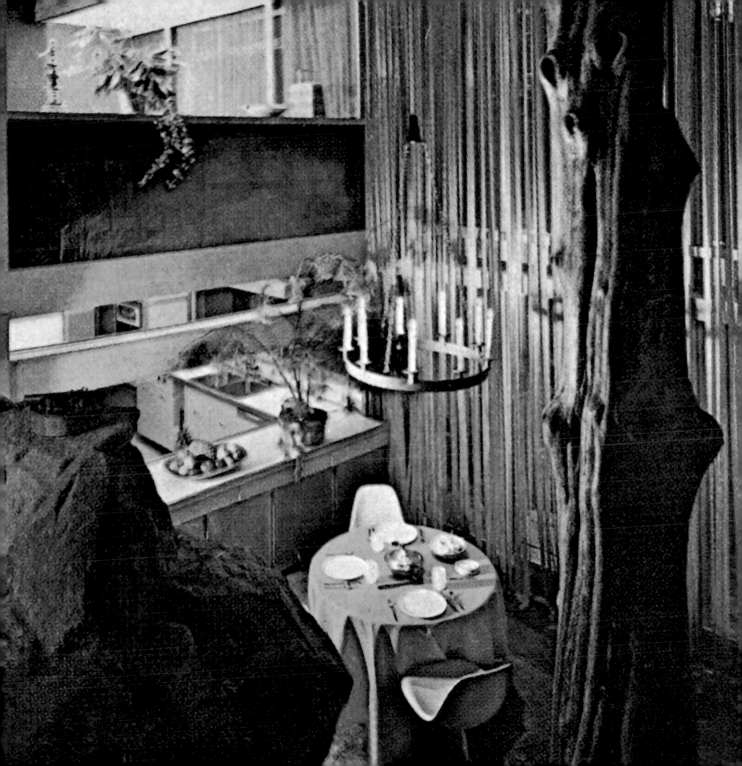

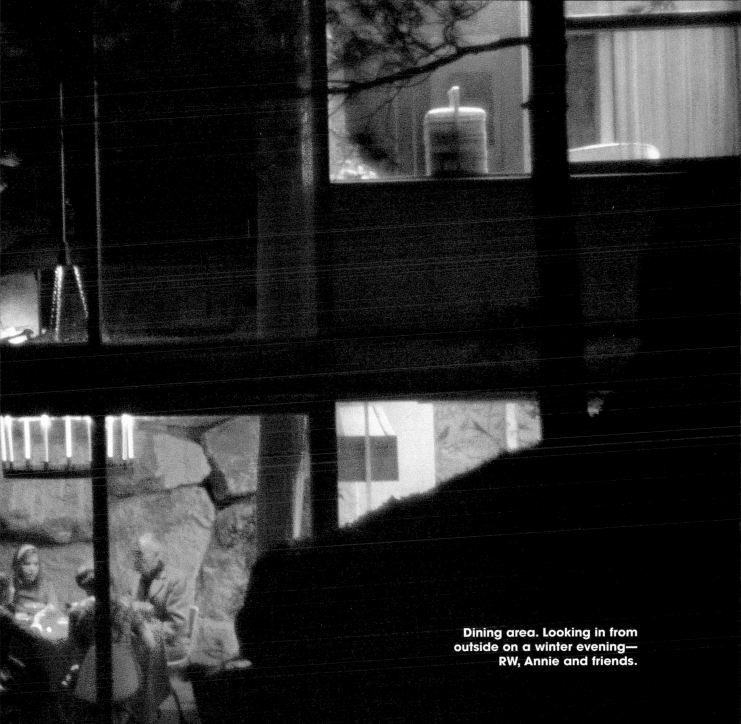

Dining area. Looking in from
outside on a winter evening—
RW, Annie and friends.

RETHINKING THE DINNER TABLE

Serving a meal occurs roughly a thousand times a year in the American home. For one sample meal served in the conventional way—a family dinner for four—we counted the number of separate pieces carried to the table: there were 82. The menu was soup, roast, mashed potatoes, one vegetable, gravy, salad, gingerbread with whipped cream; there were no guests, no cocktails or wine. Here is the list, and beside it our Family Cafeteria Dinner setting, which slices the number of pieces by more than half.

Since man has outgrown the cozy custom of dipping into the common bowl with his fingers, there is an irreducible hygienic minimum of tableware. But it is convention that piles on the extras. There is no good reason why salad can't be eaten with the dinner fork, and on the dinner plate. And why not put the bread and butter on the dinner plate too, and spread the butter on the bread with the dinner knife?

We realize that all these short cuts may sound extreme—and we know that they can look slipshod and tawdry, too. But we also know that they can look and be charming, smart, and even beautiful. It's all in the way you do it. Our main thesis here is that formality is not necessary for beauty. It shows not less, but more, respect for the good things of life to plan an easier, smoother-running meal in a setting that suits its purpose—and to have more time in which to enjoy the meal and its setting.

Conventional Setting	Family Cafeteria Setting
1 tablecloth	--
4 fabric napkins	4 paper napkins
4 dinner plates	4 dinner plates
4 soup plates	--
4 salad plates	1 wooden salad bowl
4 bread-and-butter plates	1 butter dish
4 dessert plates	4 dessert bowls
4 water glasses	4 water glasses
4 cups	4 coffee mugs
4 saucers	--
4 knives	1 cutlery tray (holding 4 knives, 4 forks, 4 spoons)
4 forks	--
4 salad forks	1 scissor salad server
4 soupspoons	--
4 dessertspoons	--
4 butter spreaders	1 butter knife
4 teaspoons	--
1 meat platter	1 casserole
2 vegetable serving dishes	--
1 gravy boat	--
1 dessert serving bowl	1 dessert serving bowl
2-piece carving set	--
1 gravy ladle	--
3 serving spoons	3 serving pieces
1 salt	1 salt and pepper set
1 pepper	--
1 sugar bowl	1 sugar bowl
1 cream pitcher	1 cream pitcher
1 bread basket	1 bread basket
1 water pitcher	1 water pitcher
	1 coffee maker (and server)
Total: 82	**Total: 36**

—Mary and Russel Wright,
Guide to Easier Living
(New York: Simon and Schuster, 1950)

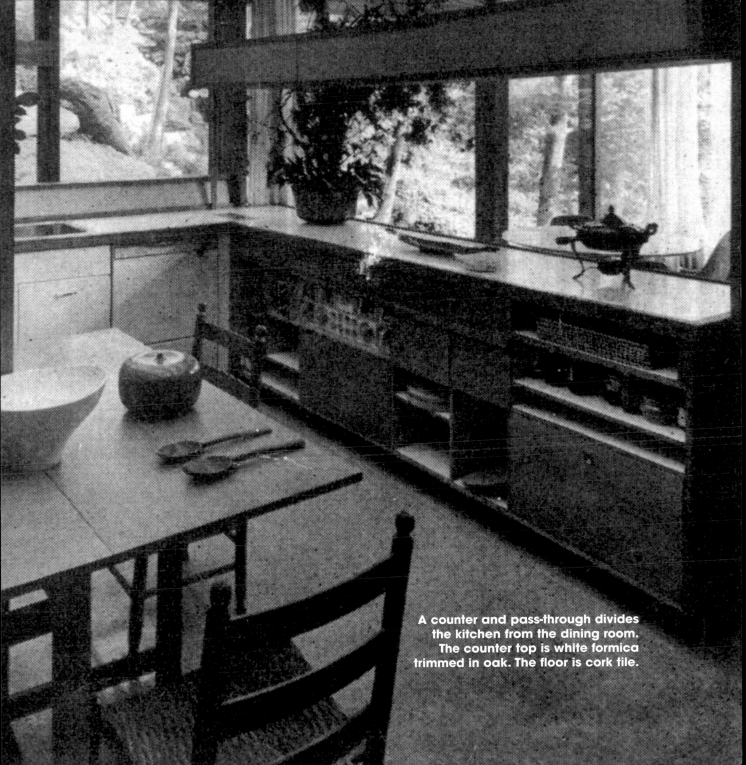

A counter and pass-through divides the kitchen from the dining room. The counter top is white formica trimmed in oak. The floor is cork tile.

VEAL STEW
MIXED GREEN SALAD
BOILED POTATOES WITH DILL
OR RICE
: DARK BEER
APPLE PIE or *STRUDEL*

Recipes:

VEAL STEW
(Serves 6)

2 lbs. shin or shoulder of veal
2 large onions (chopped)
1½ tsp. paprika
dash of red pepper 2 tbsp. crisco
salt to taste 1/2 cup tomato puree

Heat fat; add onions and sitr, but do not brown.
Cut meat in squares and add to pan, with salt,
paprika and pepper, simmer for 1 hour; add tomato
puree and simmer for 30 minutes.

Mix 4 tbsp. sour cream, 1 tsp. flour and some
meat gravy; add to pan with the meat, blend well
and simmer 5 minutes more.

Serve with sour cream made pink with paprika.

SALAD

Place in bowl as many of the following greens as
can be found:

 lettuce
 watercress
 romaine
 chopped scallions or chives
 endive
 young spinach leaves

Mix well with French dressing:
 (or alternate with Wishbone
 French Dressing)
 1/4 tsp. salt
 1/8 tsp. paprika
 1/8 tsp. white pepper
 1-1/2 tbsp. vinegar (tarragon)
 1-1/2 tbsp. lemon juice
 6 tbsp. salad oil
 1 clove garlic, chopped fine

Shake well or beat with rotary beater.

STRUDEL *Mrs Hurbst - Warm before serving*

See Service on other side of page.

SERVICE FOR NEW YORK HOUSE:

 Yellow check cloth
 Chutney stacking server and plates
 Beer in white or brown glasses
 Pie in white glass plates
 Salad in wood bowl with salad scissors
 Stew in one stacking section
 Boiled potatoes or rice in other stacking section

SERVICE FOR GARRISON HOUSE:

 Potatoes in covered orange lacquer bowl
 Stew cooked & served in yellow "Clover" deep casserole
 Service plates, cups & saucers; yellow
 "White Clover" pattern
 Beer or ice water in thick pale green French glasses.
 Salad in wood salad bowls or salad plates.
 Pie on wood plates.
 Sour cream sauce served in small mustard colored
 bowl with wood spoon.
 Cloth: Orange & gold large checked, with gold
 color linen napkins.

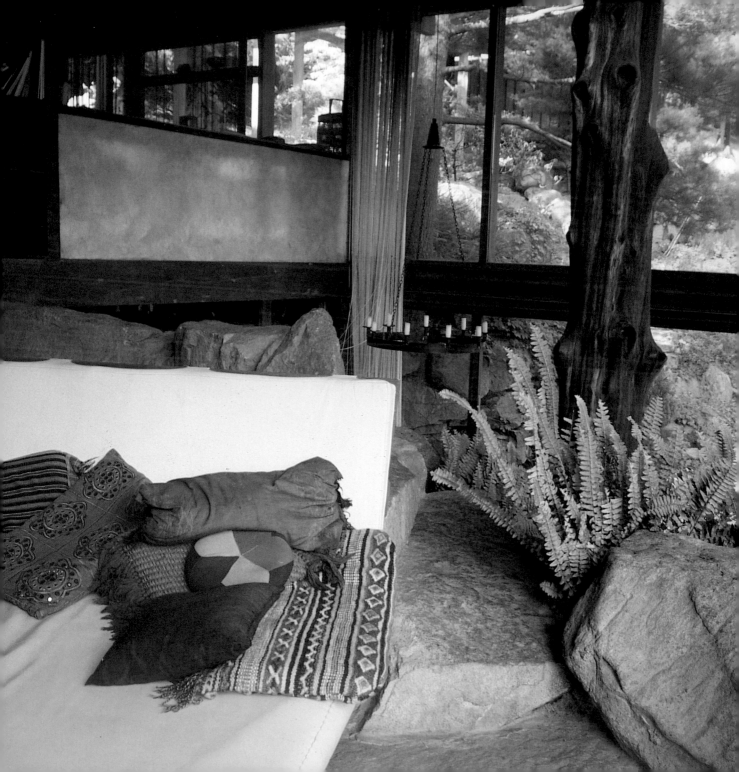

Left: Living room view of den-mezzanine above and steps to dining area below.
Right: Hall in Annie's area. The plastic panels on the right were designed by RW for Dupont in the fifties.

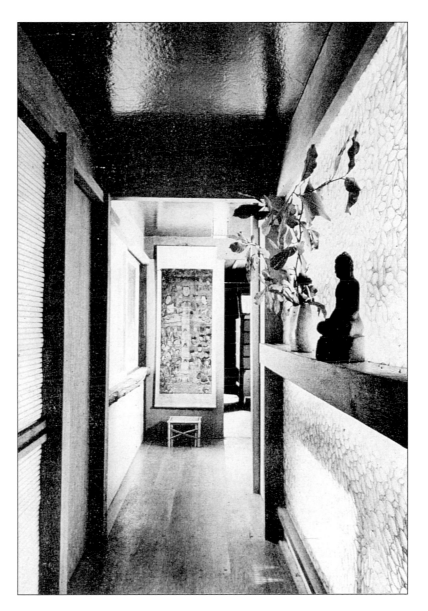

Annie in her sunken
tub, tiled with
Murano glass in
five shades of blue.
The sliding door
holds one hundred
butterflies between
plastic panels.

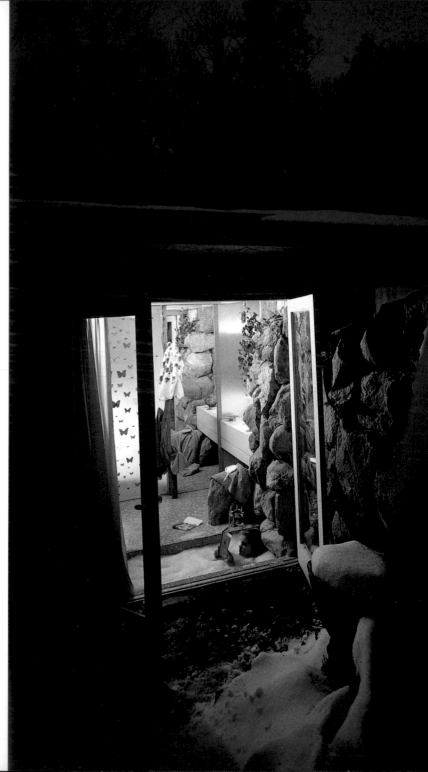

la **maison française**

Une moisson d'Idées pour l'aménagement, la décoration, les jardins

Meubles d'Alsace

N° 184 - FÉVRIER

Annie's bedroom, shown on the cover of *La Maison Française*. Its magical combination of contemporary and Victorian creates an enchanting place for a little girl. It had a miniature fretwork reed organ, cuckoo clocks, temple bells hung outside the windows, and walls covered in pink foil. The hand-painted blind pulls down to hide a wall of shelves.

Articles about Dragon Rock and Manitoga also appeared in *House Beautiful, House and Garden, Interiors, The World of Interiors,* the French *Architectural Digest,* and *nest,* among others. *Life* magazine's first story about a house featured Dragon Rock in **1962**.

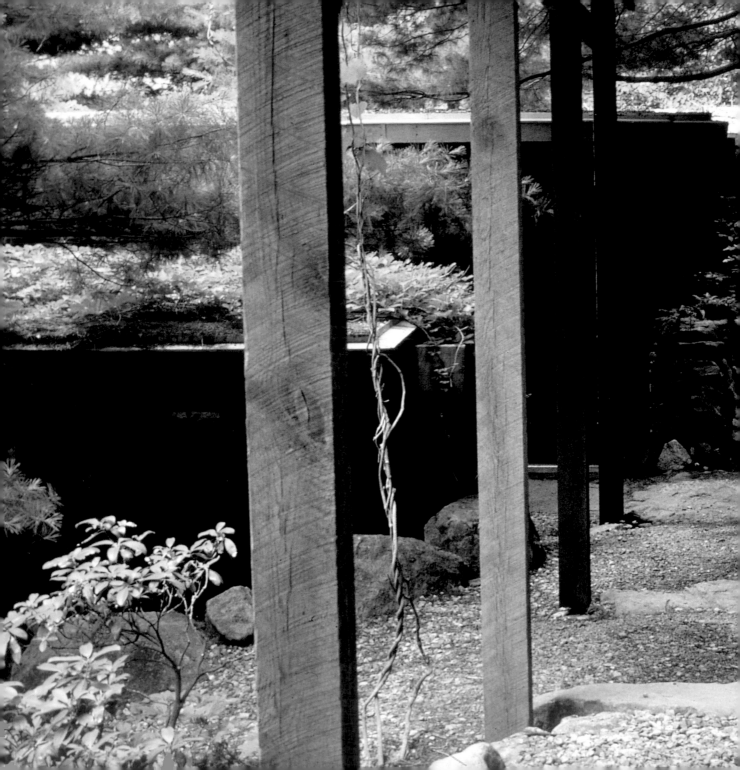

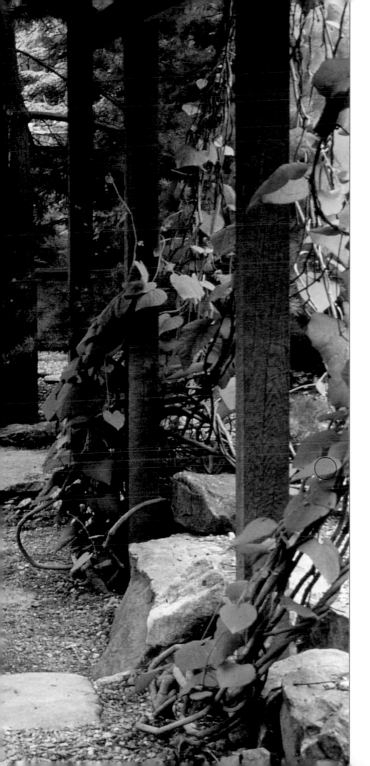

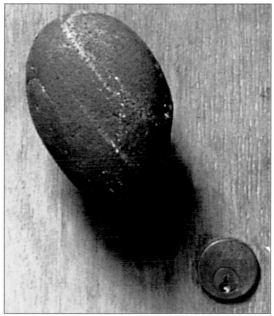

Left: Trellis connecting house to studio. Above: Studio doorknob made from a stone found on the property. Every doorknob in the house is different. Some doorknobs are made of materials found at Manitoga, such as rocks or old iron tools.

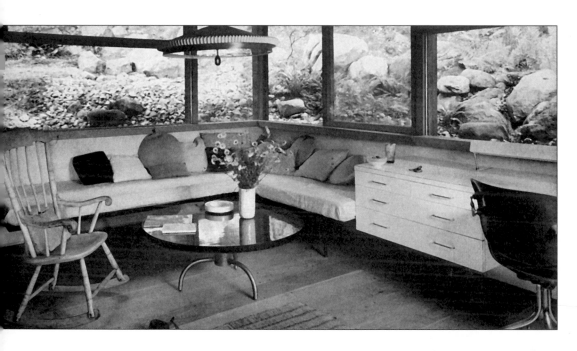

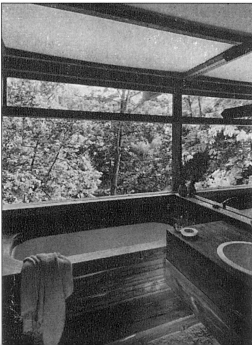

Above: Studio sitting area, shown in summer. Color and fabrics change for the seasons. The rocking chair belonged to RW's great grand-father. The table, designed by RW, raises and lowers. Right: Studio bathroom with raised tub for view and mirror providing view into the woods. Opposite page: Oak-plank divider separating sleeping section from workroom. The blue and white bedspread, shown in summer, with green sheets underneath, is replaced by a brown and red quilt in winter, with brown sheets. The white divider cur-tain is replaced by a brown one in winter. Rugs and Audubon prints also change.

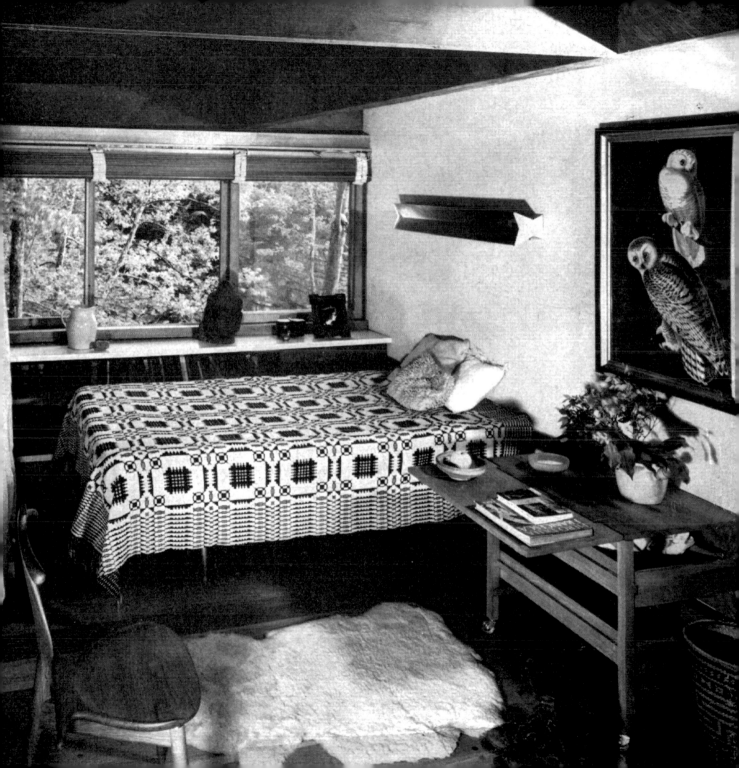

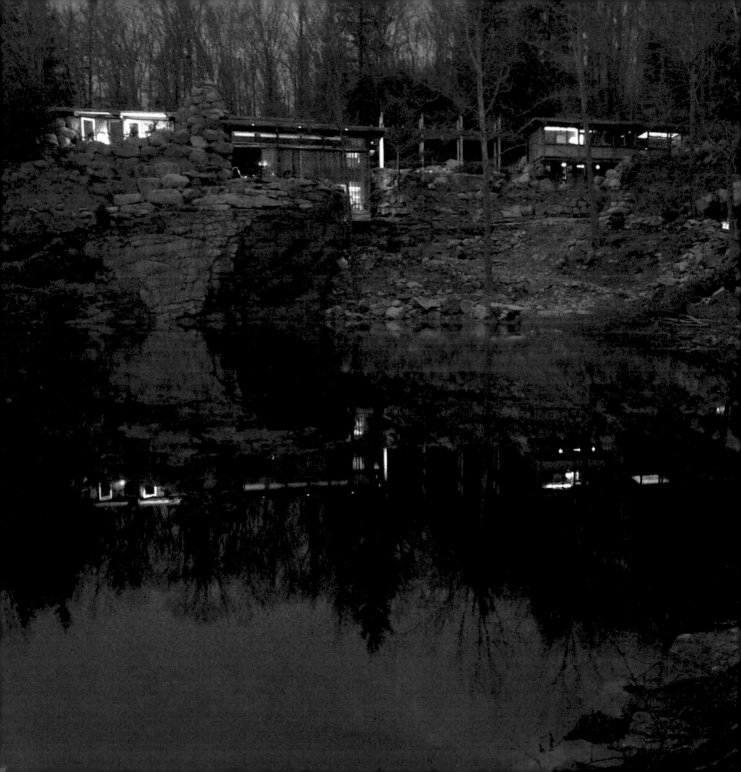

HOME FOR A NEW LIFESTYLE

Dragon Rock's interior arrangements embody many of the concepts presented by Mary and Russel Wright in their book, Guide to Easier Living. *Excerpted from Mary and Russel Wright,* Guide to Easier Living *(New York: Simon and Schuster, 1950).*

The Vanishing Dining Room

We deplore the passing of the American farm kitchen, with its massive dining table in the center. This is not mere sentimentality. That big table was the logical place for the family to dine. The hot biscuits were really hot out of the oven, the

second helpings kept warm on the back of the stove, and Mother did not waste a step in setting, serving, or clearing.

Today, we do seem to be coming around again to the conclusion that a room used only for dining is a waste of space, steps, and labor. The dining room is already becoming extinct. You are not surprised at its absence in a modern city apartment or a new house. Thoughtful architects are murmuring against the "efficiency-size" kitchen in which there is no room for a table. The American family for which they design a home today is usually one in which the woman does her own work, and where is the efficiency of a kitchen that isolates her from the family group and costs her many wasted steps daily in the serving of meals? We actually conceive of the kitchen not only as the place to dine, but as the center of family living.

We look forward to the day when living room, dining room, and kitchen will break through the walls that arbitrarily divide them, and become simply friendly areas of one large, gracious, and beautiful room. We think that day is not too far away.

The New Etiquette

We are making a new etiquette, with a new set of manners for both hosts and guests. They are better manners, more truly gracious, because they are sincere, not a counterfeit of a vanished aristocracy but an honest product of our times. What they demand, more than anything else, is a new and more relaxed attitude on the part of all concerned.

The new hostess is one who can stay within the limits of her home budget, hours, and energy and still give her guests a good time. She feels flattered, rather than nettled, when guests join her in the kitchen to help clean up, perhaps bringing their after-dinner coffee along. But, you may protest, guests never know where to find things or put things; a kitchen just isn't geared for a lot of strangers wandering in and out.

But it can be arranged—much more easily than you may think. We can plan for that informal, relaxed kind of entertaining in which host and hostess are both freed from a continuous round of duties so that they can enjoy their guests and help the guests enjoy each other. After all, the traditional forms of entertaining have hundreds of rules and dictates, whereas the new etiquette has only one basic principle: to make entertaining less work and more play for everyone concerned.

To go along with the new hostess there's a new-style host, whose talents are not limited to mixing drinks. He's equally likely to shop for the dinner, cook it, or serve it. He and the hostess plan the work in advance, deciding, for example, which of them will answer the door and take coats, fix and pass refreshments, tend to the children. And in making their plans, host and hostess also decide on how much they can count on their guests for help.

For of course the new hospitality cannot function smoothly without the new-style guest. He may be recognized as the friend you invite most often because he (or she) is so easy to entertain. This guest knows that using the right fork is less important than helping with the party. He may be capable of doing many things, from merely serving himself to perhaps cooking the meal, which a talented guest is sometimes delighted to do. On the other hand, a talented guest who avoids helping in a servantless home is being downright rude.

Table-Settings

Good taste is largely a matter of fitness and appropriateness. Who would think of wearing an evening gown on the golf course? Isn't it just about as ridiculous to set a traditional table, complete with starched white damask and all the trimmings, in the dinette, or in a combination living-dining room? Whether or not you've ever been really sure of your taste, if the basic rule of fitness is strongly enough ingrained, we're willing to bet you won't go far astray by following the vagaries of your own taste.

Since most dining tables are in or near the living room or the kitchen these days, harmony with their surroundings becomes a major consideration. Think of your table accessories as integral parts of the decorative scheme of the room. Let your setting pick up the room's predominant colors—either by the main color used, or by carefully chosen color accents.

Tableware: Table decorations needn't be confined to flowers and candles. Think of everything that goes on your table as part of the decorative whole. An unusually handsome salad bowl, for instance, can "make" a table if you plan your setting around it. Have a few favorite serving accessories as key pieces: a really good looking casserole, perhaps an antique soup tureen.

WOO
G

DLAND
ARDEN

A TEMPLE TO ECOLOGICAL DESIGN

BY IAN McHARG
Emeritus Professor of Landscape Architecture and Regional Planning, University of Pennsylvania

Russel Wright told us that the site which he purchased in the Hudson Highlands in 1942 was nondescript, mauled by an earlier history of lumbering and quarrying. How fortunate for us all that it was he who acquired the site, for he brought several crucial skills and attitudes to bear. He was a famous designer with a national reputation. He was committed to nature, perhaps from his experience as a farm boy in Ohio. He was devoted to simplicity and natural materials and forms. However, the Ohio background would be of little help for the Hudson site. This must

be learned, which RW proceeded to do, first during weekends and holidays, later full-time when he made Manitoga his permanent residence. There he came to know the plants, rocks, soils, water, climate, and creatures comprising the site, and the successional process that would ensue. It was these that he manipulated, perhaps edited. Some species, exotic and invasive, he removed; others he managed for light and shade. Certain species he introduced, notably wildflowers; others, ferns and mosses, he cultivated.

In this process, RW identified certain locations that offered dramatic experiences or views. They in turn were linked by the pathway system, which did much to demonstrate the richness and natural history of the site.

So the distinguished designer became a field ecologist and inspired ecological designer, whose greatest work is Manitoga, a temple to ecological design, an exemplar for all designers and landscape architects, and for all ecosystems waiting to be idealized and appreciated.

If it had been built in Japan, Manitoga would be a national monument, visited by processions of pilgrims. Japan has many such sites—Rioanji, Saihoji, Katsura, and more—but the United States has only Manitoga, the temple to managed succession, inspired ecological design. It deserves to be much more widely visited and emulated. Could we have idealized ecosystems throughout the nation?

In 1992, on the occasion when I received the National Medal of Arts from President Bush, he said to me: "Professor McHarg, it is my earnest hope that the art and science of the 21st century will be devoted to restoring the land."

May it be so. Let Manitoga be its best example.

Ian McHarg, who died in 2001, was an internationally recognized pioneer in the field of human ecological planning. He helped establish the University of Pennsylvania's department of Landscape Architecture and Regional Planning in 1955, and in 1960 was co-founder of Wallace, McHarg, Roberts and Todd, a distinguished landscape architecture and planning firm in which he was a partner until 1981. His books include To Heal the Earth *(1998) and* Design with Nature *(1969). Among his many awards is the Japan Prize in City Planning, which he received in 2000.*

PASSION FOR NATURE

RW offers a humorous account of his interest in nature. Excerpted from Russel Wright, "Garrison Slide Lecture, April 1961."

The best way of describing myself is to use the results of authoritative tests. A few years ago, I employed a part-time personnel man to interview people I was employing. He used a fascinating test called the Kuder Preference Test. It was made up of 300 questions. The applicants were given a stylus and would punch these questions. Then, the personnel man would fold the test and read off the result and grade the applicant in terms of the percentiles of his interests. I took one of these tests, unknown to the operator, and did it one night in bed, and then put it among his papers. It came back along with the papers of the applicants that he had seen that day; and under the heading of Comments I read: "Do not employ this man. He is fit only to be your gardener." This test did truly evaluate my interest; I am more interested in nature than any other subject.

PORTFOLIO

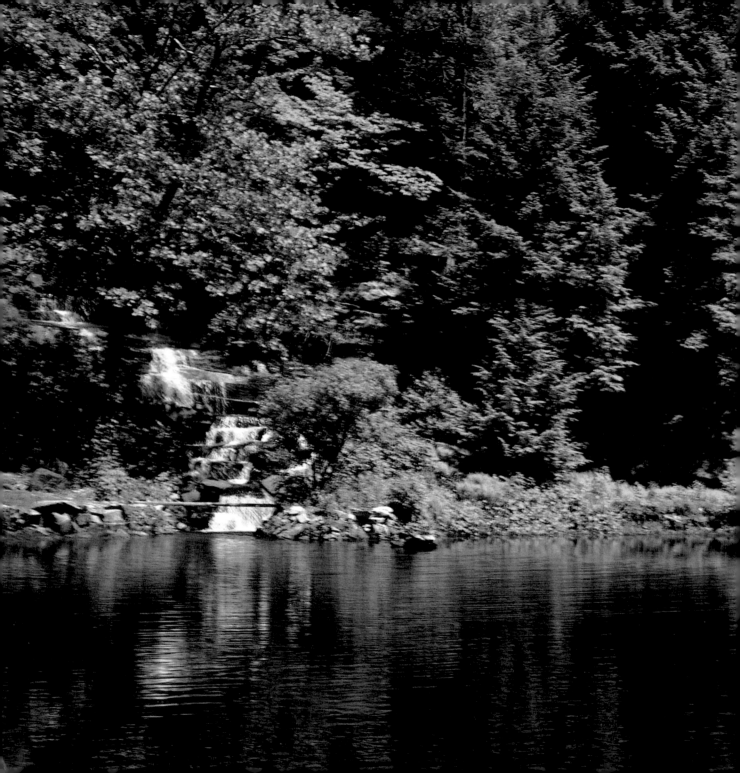

Waterfall and pond. RW created the waterfall by diverting a small stream to fall over the quarry cliff. He positioned large boulders in the stream to enhance the sound and visual appeal of the falling water. The pond was formed by damming up the far end of the quarry.

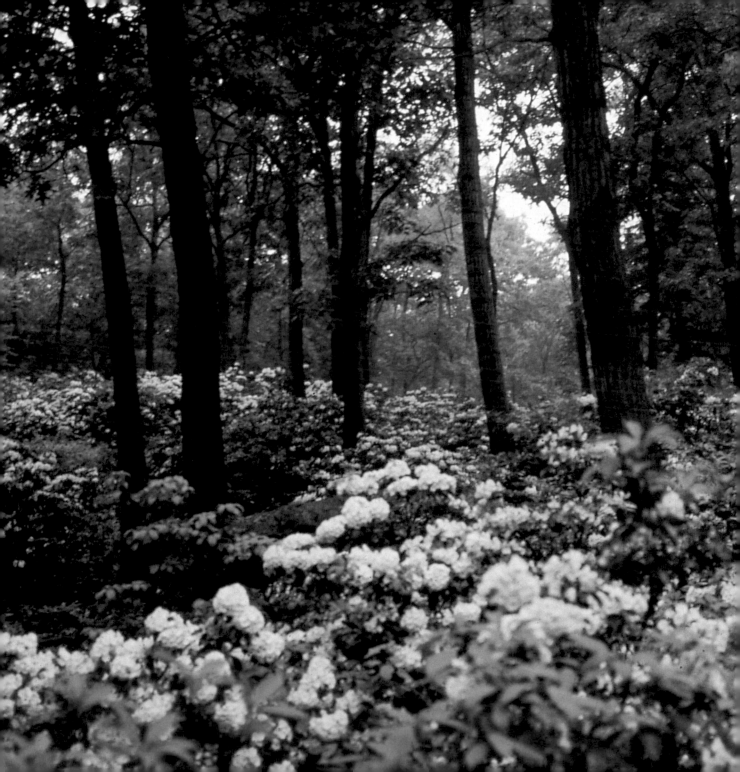

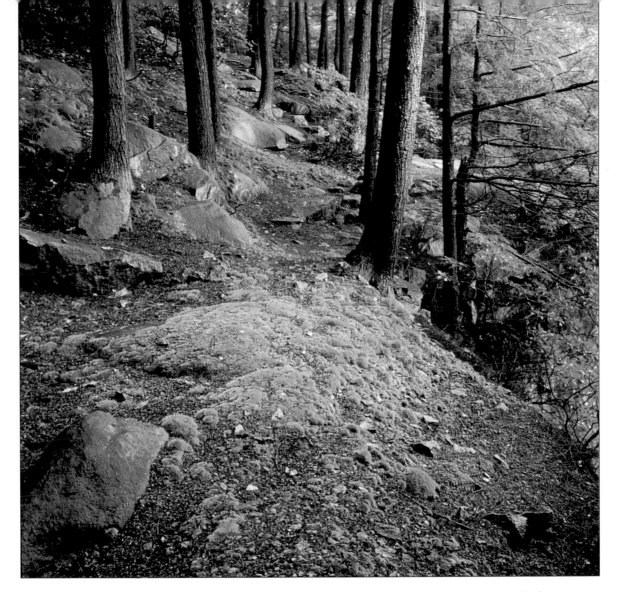

Above: The moss room. RW encouraged the growth of moss by selective removal of surrounding plants, then added more moss to dramatize the area. He made a number of rooms on the property to feature certain plant species.
Opposite: The laurel field is a good example of a large room. RW trimmed the oak trees high to enable sun to reach the laurels. He described this room when in bloom as looking like "a field of strawberry ice cream."

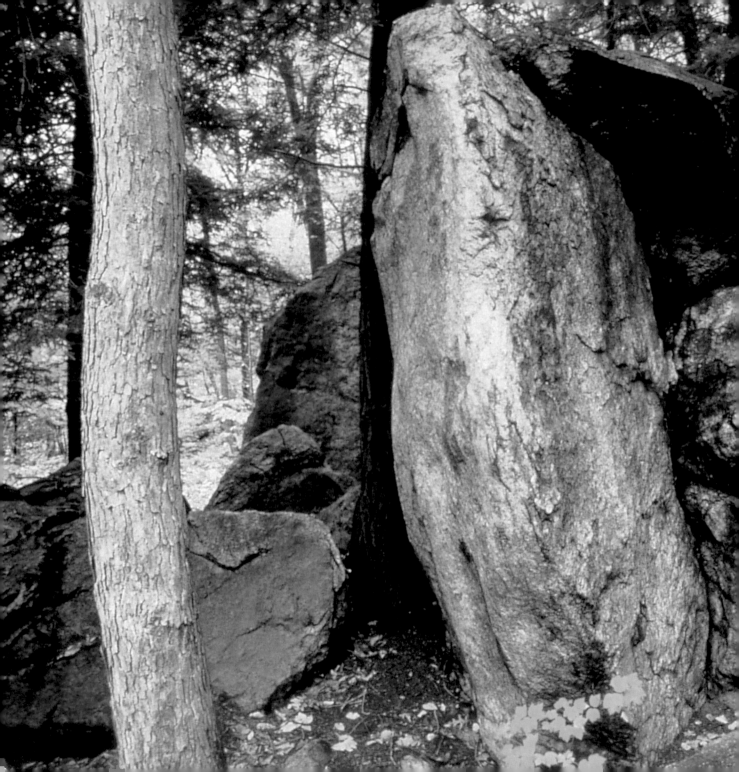

Above: Young ferns at beginning of trail. RW designed the trails to lead visitors into experiences of the natural environment.
Opposite: One of many natural stone sculptures. RW dramatized each sculpture by clearing all the plant growth around it.

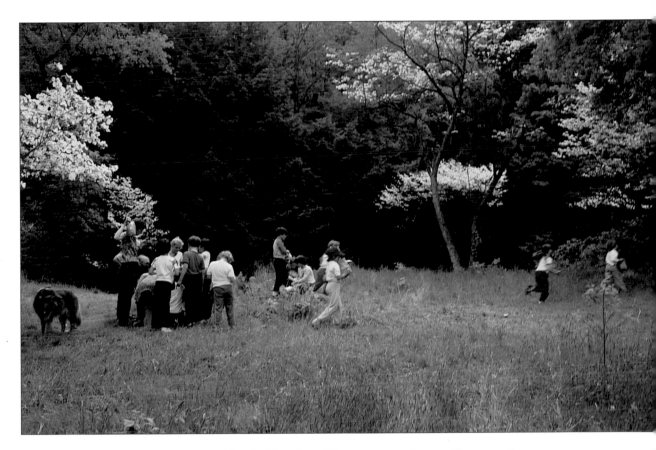

Above: Visiting school children in Mary's Meadow. Classes come from a five-county area to experience RW's design for living in harmony with nature. RW surrounded the meadow with dogwoods.
Opposite: Lost Pond, on an upland trail.

Two views of the Hudson River. RW framed small views along the trails to showcase important features.

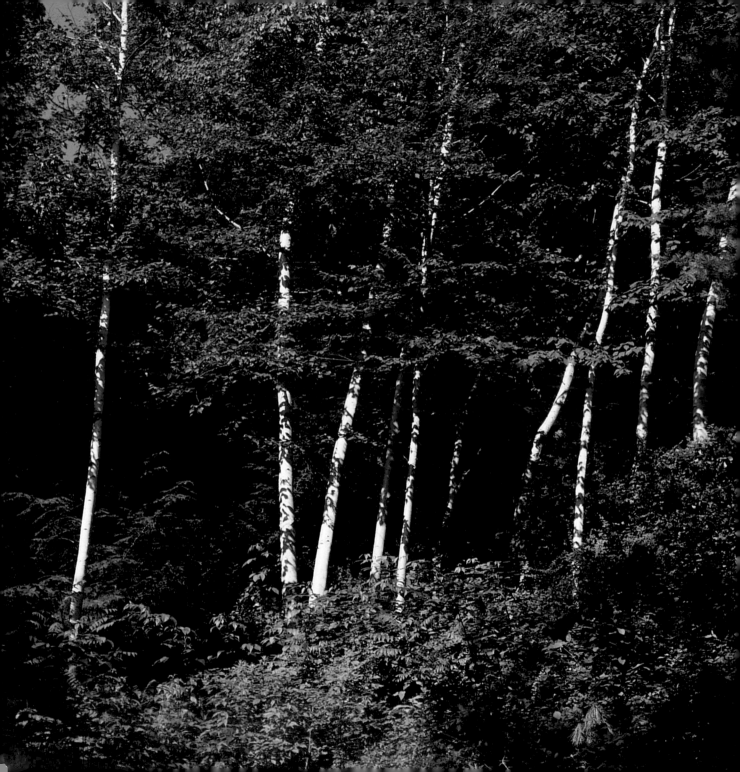

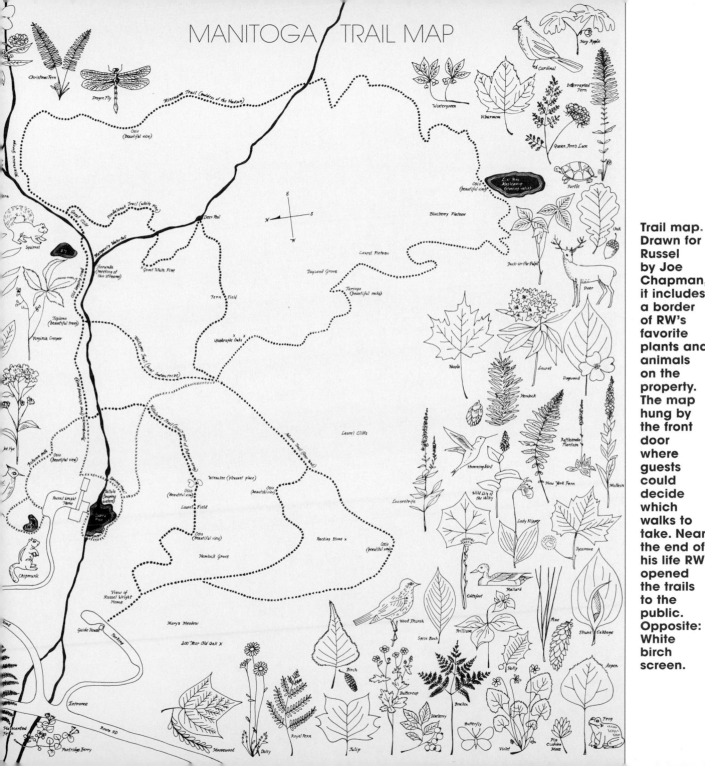

MANITOGA TRAIL MAP

Trail map. Drawn for Russel by Joe Chapman, it includes a border of RW's favorite plants and animals on the property. The map hung by the front door where guests could decide which walks to take. Near the end of his life RW opened the trails to the public. Opposite: White birch screen.

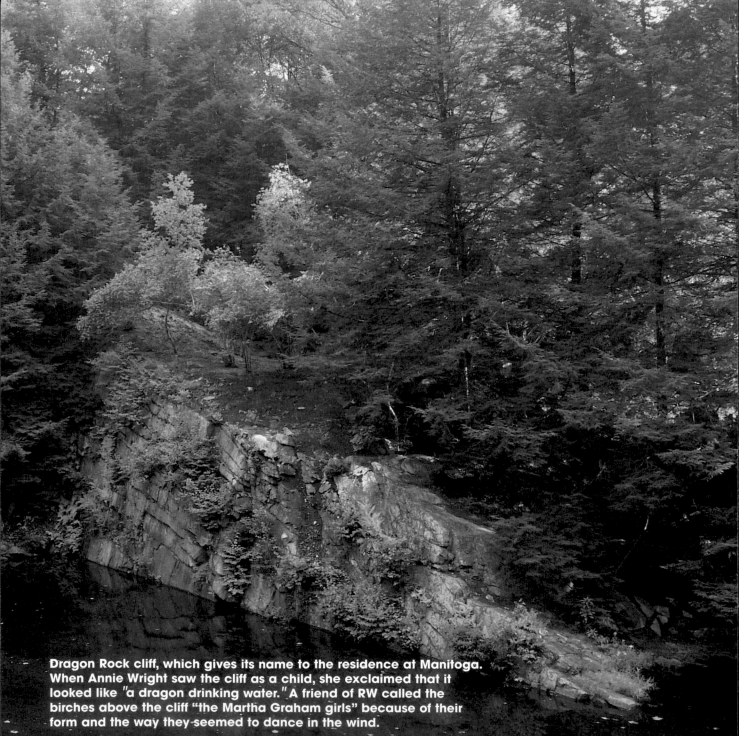

Dragon Rock cliff, which gives its name to the residence at Manitoga. When Annie Wright saw the cliff as a child, she exclaimed that it looked like "a dragon drinking water." A friend of RW called the birches above the cliff "the Martha Graham girls" because of their form and the way they seemed to dance in the wind.

DESIGNING WITH NATURE

RW describes the principles and processes by which he transformed Manitoga into an ecologically attuned landscape. This essay, written for House and Garden *magazine (which ran a shortened version in 1971), is reproduced in its entirety, as published by Manitoga in 1996.*

A Garden of Woodland Paths

The land which I bought 25 years ago, in 1942, was a nondescript piece of woods on the side of a hill where similar woods stretched for 15 miles. This is called second growth because it is the remains of firewood operations of 80 years ago, and it has been considered useless because of the lack of soil and of any level spaces which could be used for farming.

These hills have grown into the typical monotony which nature produces unless man or the elements disturb the overall repetitive pattern. It is typical uninhabited, uninviting dry and impenetrable woods, with no views or vistas.

Today, my land contains two miles of paths, many vistas of the river and the mountains beyond a large natural pool with a waterfall. Friends and neighbors consider it a fascinating and unusual piece of land, and I am amused and pleased to often be asked, "How did you ever find such an unusually beautiful site?"—pleased because these friends think that I found it this way, and therefore I know that it looks natural. Actually, a very small percentage of it has been thinned, and no formal landscaping has been done, and only indigenous growth is allowed here.

In the beginning, our small bungalow was so closely surrounded by woods that my wife was unhappy with it. It was hot and claustrophobic, so I began to cut back around the house to create a gradual transition to the woods, and I began

to explore the possibilities of a view. In my explorations, I found many interesting features on my land—great sculptural boulder formations, cliffs, small ravines, large areas of ferns, and some giant trees, and by climbing some of them, I discovered great vistas of the river. So, I began cutting views, and I am still doing this. Thinning must be done slowly and carefully over the years. No big openings may be made or the trees, not having time to accustom themselves to wind, will topple and you will lose some. So I cut only a few trees at a time. I take photographs and then make tracings over them to decide on what trees to eliminate. Sometimes only a few limbs are cut to reveal a bit of the river.

In the course of this slow process of thinning, I grew to know and to love my land. I felt that it was unappreciated, and I wanted my wife and weekend visitors to see the beauties I had discovered. Thus began weekend projects of making paths. It is the story of the making of these paths which I would like to share with others. The protective land which many of us have acquired around our weekend places need not be an unloved, unenjoyable tangle. It can be much more than a wall separating you from your neighbors. With small effort, it can become a wonderland for your children, or a revitalizing stroll for your guests.

Here are four simple general rules for planning the paths:

No. 1. Follow the natural contour of the land. Look for a path which the dogs, the deer, the cows or the rabbits may have made and use it as the inspiration and base of the plan. Unless you are trying to develop an allée, avoid straight lines. Make paths which always curve.

No. 2. If possible, make it unnecessary to retrace your steps on a path, that is, make it complete a contour.

No. 3. Plan it to show off the most interesting features of your land. Have it pass through a bed of ferns; turn around a knoll or a rock formation. Find a good place for picnics. Open a place where there is a vista. These features

should be placed not on the side or the straight line of your path, but your paths should be arranged so that they are in a portion of a curve, that is, the interest of the path can be sustained if the walker finds a feature or change as he turns a curve in the path.

No. 4. Vistas should be cut very slowly, as I have stated above. Do not make the usual crude mistake of a panoramic vista by cutting down everything in front of the viewer. It should be framed with large trees, and have many trees between the viewer and the vista to create more depth and a subtle, natural effect.

The labor of making paths need not be great. I recommend that you limit yourself to weekend projects because if it is left entirely to hired labor, much will be destroyed that could have given you much pleasure. Mine have been made merely by my own work, occasional help of guests and of "moon-lighting" laborers and, in a few instances, I have retained professional tree surgeons.

The techniques are primitive, and workmanship can be unskilled. After I have determined the course of a path, I begin by heavily spraying the growth on it with a brush killer. Within a year's time this growth has been killed and falls to the ground, or the roots can be easily pulled. Where there are rough spots, you use a grub hoe and smooth out the terrain. A path is oppressive and dull and uninteresting if the growth on both sides all the way forms a kind of solid wall. Therefore I make openings of alcoves to relieve the walled-in effect, which can be desirable just preceding a panorama.

Thinning can be done by cutting down (be sure to cut the roots) small sickly trees, but generally leaving those which are healthy and straight. A complete thinning can be done where you would like to show a small grove of a certain kind of tree or shrub, cliff, or a group of boulders.

If you find some interesting wildflowers or ground cover, weed out all of the other growth which surrounds it, and encourage it to spread, or you can even buy from wild nurseries plants of the same kind to increase the area of the wildflowers.

If there is an interesting feature at some distance from the path, make an offshoot off your main path into the feature.

Here is a list of tools which I use for my very rugged land: grub hoe, bush-whack, machete, aerosol spray, portable spray tank, pruning clippers, ax, pruning saw, shovel, chain saw, baskets, crowbars, pick, sickle.

I have used three types of construction for paths:

No. 1. The easiest is a cross-country or through-the-woods path which is really not a path at all. I either blaze with an ax a small cut in trees to mark the path, or with an aerosol spray of an orange color, I make a spot always at eye level on the right side of the way that I have found it easiest to go through the woods. This is an intriguing kind of path that your more enterprising guests may enjoy.

No. 2. A single file path.

No. 3. A double path, that is, a path on which two can walk together comfortably. If your land is rough, this is a great deal more labor naturally than single file. But it is friendly and more comfortable.

I like to give each of my paths a theme. Here are a few suggestions:

A Morning Path leading toward the east so that the sun shines through the trees as you walk.

A Sunset Path leading toward the west, if possible with a sit-down place for watching the sun.

A Springtime Path that shows off the wildflowers that bloom in the spring.

An Autumn Path that shows off the great variety of fall color in your trees and shrubs.

A Winter Walk which is predominantly evergreen.

If you want novelties, there are two that I can suggest: I have a place which I call a secret room. It could also be called a sanctuary or retreat. I have disguised the path to it so that no one knows how to find it but myself. A very small area has been semi-cleared which is delightful to sit in or picnic in alone or with one or two friends.

A more elaborate novelty is a labyrinth. This can be made in an area where there are lots of bushes by the use of the brush killing spray, and clippers and grub hoe. The pattern of the path is arranged in such an elaborate pattern that people following it "get lost." The labyrinth path can be an attraction for small children.

The first woodland path I made is short (fifteen minutes) but carefully executed. It starts close to the house and returns to the house. I use it as an introduction to Nature. My most urban guests can walk it in a short time and feel that they have gone through the woods. It is designed for spring and summer strolling, and many elements are arranged to make it seem and feel cool as ours is a very hot region in the summer. It begins with crossing a simple bridge over the waterfall. This region naturally has many boulders and rocks in it, and I have added many more from places where I do not want them. Growth among the rocks is removed and prevented because I want the path to begin with a barren feeling to contrast with the lushness to be found further on at the first curve. Here the path, padded with thick moss, runs between many hemlocks, underneath which are the glossy dark green laurel bushes which I have planted there around the pool. The lower branches of the hemlocks have been removed so that you can look down through these trees to the water in the pool. On the sides of the path, small paths or stone steps lead to alcoves which I call rooms. There is a little hollow that you look into which is carpeted with a wonderful growth of partridge-berry. There is a room whose walls are tall hemlock. It is inhabited by a huge family of many sized boulders, and between these I have seeded a large amount of wild thyme, always fragrant. In the next one, the main planting is of the silvery leafed sweet everlasting (it has a white flower), mixed with the feathery lady fern and surrounded by huge bushes of laurel, in back of which are more hemlocks, and in the distance the white trunks of canoe birches.

Hepatica is planted on both sides of the stone steps leading to the lady's slipper room. The lady's slipper and the other wild orchid, rattlesnake plantain, have seeded themselves in many areas outside this room. In fact, they form the overall pattern of the whole walk.

Manitoga is one of a handful of models of positive human relationships with the natural world—capturing a vision of man as part of the organic life of the landscape. As a native American garden, it is critical to the psyche of our society, revealing the drama and richness of the Hudson Highlands and demonstrating alternative ways to live in our precious land.
—Carol Franklin, FASLA, *Andropogon Associates,* **1998**

This is the highest point of the path and here you can carefully step out on the crown of a sheer granite cliff which drops straight down to the water of the pool thirty feet below. You look across the pool, the trees beyond the dam, and see a bit of the Hudson River and the mountains on the other side of it.

A curving flight of stone steps leads down to a mossy plateau where I cleared all trees except a small grove of twisting grey birch. A friend has dubbed them the Martha Graham girls, because they look like dancers. In the spring the moss is dotted with tiny bluette flowers. Here one always pauses to look across the pool to the waterfall and its fifteen cascades. Next you pass by hemlocks in front of which I have planted chickory whose grey leaves and blue flowers contrast with the somber trees.

A path of New York ferns has been annually weeded so now it makes a great furry swath which sweeps around the curve here.

You walk down through a clearing of field grass and wild strawberries and then cross the dam on stepping-stones.

The shallow end of the pool offers fish, underwater plants and reflections to enjoy. Stone steps lead you from the pool to a path which curves through a small grove of dogwood.

For the final lap of the walk I wanted a more civilized mood so I created a small pastoral hill. At its base are two field cedars flanking a big comfortable boulder on which you can sit and look back across the water at all you have walked through on this excursion. Finally, you climb the sun-drenched hill sprinkled with daisies, butterfly weeds, bladder campion, and Queen Anne's lace to the living room terrace which is shaded by tall sycamores.

Thus my guests have experienced in a concentrated area samples of much that my land can offer—boulders, cliffs, dark hemlock groves, sunny fields, vistas and the water, all in a fifteen minute walk on a path which goes up and down, and provides a little exercise as well as interest—a good idea before lunch or dinner.

Another of my paths doubles as the Morning Walk and the Winter Walk. The direction of the path is entirely eastward so that in any season that you walk up this hill before noon, the sun will be shining at you through the needles of the hem-

lock, and will be strong on the tops of the large trees, where the birds fly and the squirrels leap. Below you will see the sparkle of the little cascades of the brook.

The path follows an old path which a hundred years ago was used for sleds to bring cordwood down the hill. I found that along both sides of it small hemlocks were predominant. Twenty-five years ago I started cutting out almost all of the deciduous trees edging the path. Now I thin the hemlocks to eliminate the scrawny ones and to encourage the strong ones. It has gradually developed into a majestic alley of these dark evergreens.

Most of this path is at the base of two embankments so that there is always a deep deposit of leaves underfoot—soft and quiet for walking. At the beginning of the path the sides are so high that one has a worm's eye view of the trees from both sides. As you ascend the hill, the sides diminish so that they become eye level and you look at the base of the trees in the woods. You pass through a forest which I purposely leave untouched. It is rather like looking at the bottom of the sea through a glass window. Here you witness the dramatic cruelty of the forests. The corpses of fallen trees are being devoured by decay or are caught in the arms of younger ones. Roots attack the boulders. Often you hear the flutter of the wings of partridge and see them flying away deep in the woods. In the early summer many Indian pipes push their way through the leaves of this path and after every rain there is a great crop of mushrooms.

Lest the path become a monotonous alley, I have cut two openings. The first opening shows a bend in the brook where the ferns sweep knee deep down to the water.

At the next bend in the path, I have widened it to encourage the natural carpet of white violets that grow here, and to reveal a small waterfall, a large area of flat rock, and a small clear, clean pool just large enough for one person to

The woodland garden at Manitoga bridges the gap between nature and the human gardener with such subtlety that Wright's hand is nearly invisible. Its beauty is in the heightening of contrasts, the focusing of views, and the celebration of the plant communities that thrive there. There are lessons for every gardener in how to see one's surroundings and adapt them harmoniously to a personal vision.
—Antonia F. Adezio, President, The Garden Conservancy, 2000

bathe in. This opening is an ideal setting for a picnic. Overhead I have cut a large grapevine so that you can grab it and swing out over the brook. In the next portion I have removed the hemlocks to reveal on both sides my tallest trees, which tower eighty feet. This is the best place to see and hear the birds. Here we have on three occasions found the skeletons of deer in the snow, and picked up the tail feathers of the vultures who had eaten the flesh from the bones.

Next I bent the path to run close to the brook and I have cleared out the fallen trees to show the great expanse of the giant leafed skunk cabbage.

The path again plunges into a hemlock tunnel which curves away from the brook and then back again at the crossing made by four large boulders moved here for stepping stones. In wet weather, the water rushes past between them.

On the other side is the goal of this path: a grove of hemlocks all the same size stretches along a narrow strip of the bank on the other side of the brook. Back of the brook a huge stone, 25 feet high, forms a long wall. The grove of hemlocks continues for about 150 feet along this magnificent cliff. You can walk along under the hemlocks looking up and admiring the contours and the rich pattern of the lichen of this giant stone. At the end of the grove, one can recross the brook at a lower point and return to the hemlock tunnel.

My Sunset path also doubles as the Autumn path. It starts as an offshoot of the Winter Walk. The entrance is marked by a few big stone steps which take you over the embankment. To draw one's attention from the main path, I have planted four new birch whose white trunks are seen through the dark hemlocks. As you reach the top of the embankment, it is late afternoon, and you see these dramatically lighted against the screen of hemlocks. Around them I have transplanted witch-hazel bushes whose yellow blooms last through late November.

On the other side of the path I have left a baffle of maple and hemlocks to hide the approach to the surprise feature of this walk. As the path turns, you suddenly see the main feature—a theatrical scene at sunset—through the trees (which have been thinned); the setting sun shines from the back of a distant mountain on the Hudson River. The path leads to a window-like vista which is framed by ancient hemlocks and a formation of some 18-feet-high boulders.

Parts of this granite sculpture form flat platforms large enough to hold a picnic or several spectators of the sunset. The upright members of this sculptured composition are great for climbing and exploration. This complex is sheltered by several huge 150-year-old hemlocks, and this is where one finds patches of fur so that you know this is where the deer bed down. The path runs through this huge sculpture and then makes a steep descent, and turns again to reveal another surprise vista: through the trees you see a long horizontal shining streak made by the sun on the Hudson. At your feet and around you is a small sea of viburnum which are many shades of wine red in the fall.

Below, across the paths, I have planted a long horizontal drift of deep purple aster and beyond there is a family of small boulders, among which I have planted trailing bittersweet because of its bright yellow leaves and berries.

Continuing, you will find that I have thinned the woods to make an opening on one side to reveal a beautiful cliff which is about 200 feet from the path.

Further on, on the other side, the clearing made for an old trash pit has been covered and seeded with the weed called Indian tobacco whose red blooms in September are repeated by the leaves and berries of the dogwood which surrounds this little clearing.

At the bottom of the descent you begin to see the sun on the water of a small swamp. This was made by the bulldozers when they removed fill for my house, and I am naturalizing it with swamp plantings. Continuing downward are two more sharp turns and you get the full sweep of the swamp ringed with dogwood, a black willow, and a scarlet-leafed tupelo tree.

A few steps from here you find the parking area and house.

SUGGESTED READING

These works provide an introduction to the work of Russel and Mary Wright.

Albrecht, Donald, Robert Schonfeld, and Lindsay Shapiro. *Russel Wright: Creating American Lifestyle.* Catalog for exhibition at the Cooper-Hewitt, National Design Museum, Smithsonian Institution. New York: Harry N. Abrams, 2001.

Hennessey, William J. *Russel Wright, American Designer.* Gallery Association of New York State. Cambridge: The MIT Press, 1983.

Keller, Joe, and David Ross. *Russel Wright: Dinnerware, Pottery & More. An Identification and Price Guide.* Atglen, Pa.: Schiffer Publishing, 2000.

Kerr, Ann. *Collector's Encyclopedia of Russel Wright,* 2nd ed. Paducah, Ky.: Collector Books, 1998.

Opposite: Russel Wright, 1976. Inside cover flaps: Two ways RW dramatized nature. Inside front cover flap shows how he spotlighted one tree—the shad bush. Inside back cover flap shows how he featured one species— the hemlock, eliminating all others.

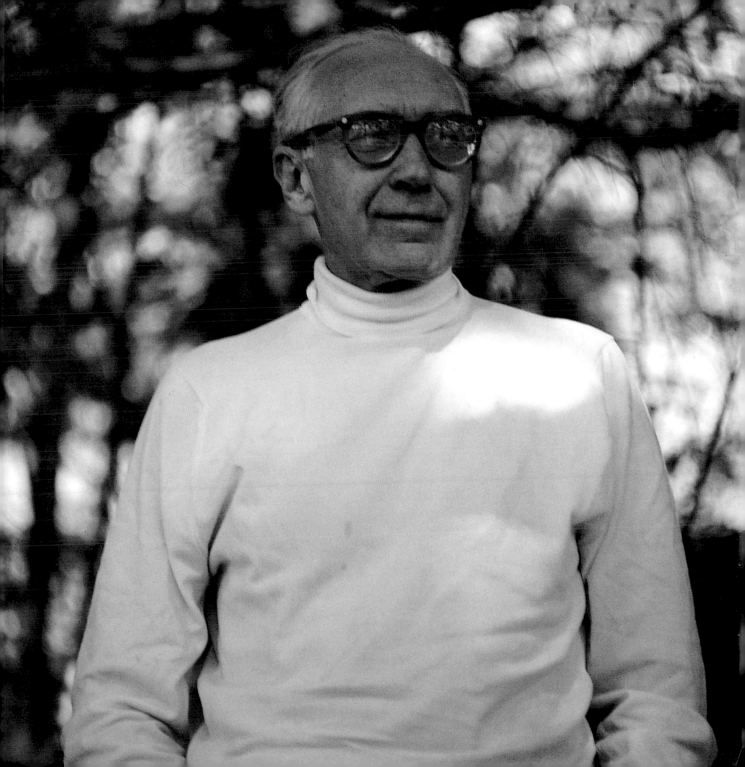